IMAGES
of America

THE LARKIN
COMPANY

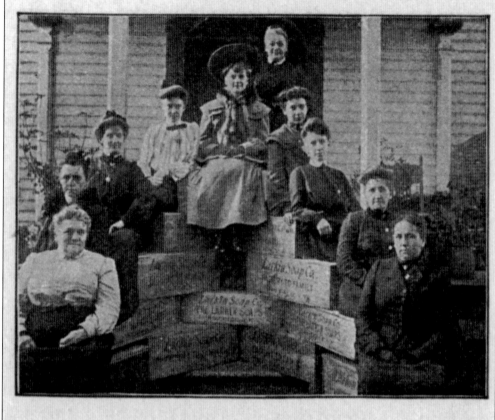

A LARKIN CLUB-OF-TEN.

MRS. CORA M. HOOPES, SEC'Y, MINERVA, OHIO.

What separated the Larkin Company from other mail order businesses in America was its use and guidance over the "Larkin Secretaries." These secretaries were the backbone of the company, creating clubs of 5, 8, 10, or 16 people, and engaging other prospective customers. During club meetings, they would each contribute a certain amount of money to a Larkin soap order and then be eligible to receive a premium. One premium would arrive every month, and each club member would receive one in turn. During the company's best year—1920—there were 90,000 secretaries setting up clubs around the country, leading to a customer base of a little over two million people. The Larkin Company would highlight various clubs around the country in its monthly newsletter *The Larkin Idea*. Pictured here is a Club of Ten from Minerva, Ohio, in 1904. (Courtesy of the Buffalo History Museum.)

ON THE COVER: This image shows the R, S, T Building, or Larkin Terminal Building, in 1924. Here, packages were checked and put into the proper mailbag. For national shipping, Larkin had a fleet of delivery trucks that would deliver packages to the Buffalo, New York, waterfront, where they would be loaded onto waiting lake freighters. Larkin also had its own rail line, which ran through the first floor of the Larkin Terminal Building. It was a branch line to the nearby New York Central Railroad. The first floor also allowed for lines such as the Pennsylvania Railroad and Erie Railroad to come directly into the building for loading. (Courtesy of the Buffalo History Museum.)

IMAGES
of America

THE LARKIN
COMPANY

Shane E. Stephenson
Foreword by Howard A. Zemsky

ARCADIA
PUBLISHING

Published by Arcadia Publishing
Charleston, South Carolina

Printed in the United States of America

Library of Congress Control Number: 2018933601

For all general information, please contact Arcadia Publishing:
Telephone 843-853-2070
Fax 843-853-0044
E-mail sales@arcadiapublishing.com
For customer service and orders:
Toll-Free 1-888-313-2665

Visit us on the Internet at www.arcadiapublishing.com

Dedicated to all the "Larkinites"—those who worked at the Larkin Company then and those who, with the spirit of Larkin, work in Larkinville now.

CONTENTS

FOREWORD

What's old is new again; this is true for the Larkin buildings of course, so many of which are well over 100 years old. Their exteriors have been restored but their interiors have been reimagined, reconstructed, and repurposed. There are now more people working in our buildings and in the Historic Larkin District than there were during the heyday of the Larkin Company. We are proud to be a family business that is reimagining the future of the Historic Larkin District.

We have been doing this for about 17 years now, but our family has commercial roots that go back to my father, Sam, and the meat processing business (Russer Foods) started in 1969 at 665 Perry Street, just around the corner. I joined him in 1981, and we sold that business about 20 years later. During those years, I traveled the country and noticed that most cities were reimagining and revitalizing their historic industrial buildings and neighborhoods. Later, my involvement with the Martin House Restoration Corporation gave me a lesson in Buffalo's architectural history and in the history of the Larkin Company, both of which were inspiring.

The Larkin Company and its senior management, including John Larkin, Darwin Martin, William Heath, and Elbert Hubbard, were risk takers; they were what we now refer to as disruptors. Ironically, the disruptors got disrupted by new technologies and new forms of transportation, just as this neighborhood did. But those leaders were never tethered to the commercial practices of the past. They were innovators in their products, their distribution systems, their customer relations, their employee relations, and of course in their structures and architecture, including their famous Larkin Administration Building, designed by Frank Lloyd Wright.

I would like to conclude where I started—what's old is new again. The advent of the internet and the disruption to brick and mortar retail is just the latest version of the old Larkin Company business model and motto: "From factory to family, we cut out the middleman." The story of America, of American business and ingenuity, is reflected in the Larkin neighborhood and its buildings, is evident in and under the streets in the old Hydraulic Canal, and is told to us both in photographs and by the families who live and lived here. We are proud to be a family that has brought its own vision and determination to bear on the rich history of and revitalization of the Larkin Historic District and of Buffalo.

—Howard A. Zemsky

ACKNOWLEDGMENTS

I have met so many passionate, modern-day Larkinites throughout the writing of this book, and it has been a pleasure listening to their stories. Humble thanks go to Leslie and Howard Zemsky, who embraced this book as they do all their developments, with enthusiasm and passion. The Larkin Company would not be getting the attention it is today if it were not for their vision for Larkinville. Sharon Osgood, Jerry Puma, and Dr. Howard Stanger brought new ideas and ways of approaching this book to me that I had not considered. Their expertise and zeal for the Larkin Company adds much knowledge to Buffalo's historical record. Thanks to Nancy Gavin Koester for her knowledge and family history with Hook & Ladder Company No. 5. Many heartfelt thanks go to Melissa Brown, Cynthia Van Ness, and Amy Miller at the Buffalo History Museum and Charlie Alaimo at the Buffalo and Erie County Public Library for their assistance. Thanks to my editors at Arcadia, Angel Hisnanick and Jim Kempert, for their attentiveness to detail in areas I overlooked. As always, the guidance and love from my parents, Bob and Carol; stepparents, Susan and Nick; sisters Sara, Catie, and Nicole; my two brothers-in-law, Dan and Steve, who helped me greatly through this process; and the newest addition to the family, Rowan. Lastly, to all the friends and acquaintances who have asked me "How's Larkin?" and have listened to me droll on about it, especially D.L.G., I thank you. Most of the images in this book come from the Research Library at the Buffalo History Museum.

INTRODUCTION

In the end, the Larkin Company's demise was the result of its most innovative creation—the use of Larkin Secretaries to promote its products. Beginning in 1920, at the company's height, these secretaries, ordinary housewives from small towns, farms, and big cities across the country, drastically slowed their participation and promotion. This is illustrated in a memo addressed to Darwin D. Martin, the Larkin Company's first office worker after John Larkin himself and an important executive, on August 24, 1921. The memo showed that "gross sales to date are 45.7% less than in 1920." It was the beginning of the end for a company that had been in existence for nearly 50 years, a place that John D. Larkin called "the works" to family and friends.

"The works" began in 1875 as a 3,000-square-foot, two-story building at 196–198 Chicago Street in Buffalo's Old First Ward. It ended up a collection of 21 buildings named after the letters of the alphabet and covering 2.1 million square feet, touted as the largest factory in the world. When John D. Larkin decided to start his own soap company in 1875, he already had 10-plus years in the soap business, working for his sister's husband, Justus Weller. During these years, Larkin worked as a bookkeeper, soap maker, and salesman traveling between Brooklyn; Manhattan; Lockport, New York; Sandusky, Ohio; and Chicago, Illinois, where Weller had moved his business. Weller eventually made Larkin a partner. At 30 years old and having worked in every position within the company, Larkin felt he had the makings to run his own business. With Larkin & Weller Co. dissolved and Larkin receiving almost $10,000, he moved back home to Buffalo with his new wife, Frances, determined to make a go of it.

Throughout his years, Larkin had an uncanny ability to bring people into the company who would innovate and adopt new applications to traditional ways of doing things. Through his marriage to Frances, he brought with him Elbert Hubbard, his wife's younger brother. Each using their unique skills, Larkin and Hubbard would create "The Larkin Idea," which launched the company to great heights. By the time the Larkin Idea was developed in 1885, the company had an excellent track record of sales. It had distributors in every state east of the Rocky Mountains and a product line of nine different laundry and toilet soaps. Elbert Hubbard, as the traveling salesman for John D. Larkin & Co., began to market Larkin products directly to women in the home. He noticed that the direct sales were becoming more fruitful than selling to dry goods stores and other distributors in various town and cities. This gave him an idea.

In 1901, a Miss Dale from the Massachusetts group coined the phrase "Save all cost which adds no value." This phrase has been attributed, incorrectly, to the beginning of the Larkin Idea, but it became the calling card for the idea from that moment on. The Larkin Idea was simple enough. Cut out all of the middlemen, brokers, wholesalers, and distributors, and market Larkin products directly to housewives. Take the money that would otherwise be invested in the payroll and create premium gifts that would be given to the customers. The Larkin Idea's first incarnation in 1886 was the Combination Box, a box for $6 or $10 that would include 142 products, 100 of which were Sweet Home laundry soap, Larkin's first product. With a purchase of a Combination Box,

the buyer would receive gifts for other members of the family, including children. Around 1900, the Combination Box, which had brought the company hundreds of thousands of dollars in sales, was discontinued. As the list of premiums grew, now marketed through the Larkin Product and Premium List, any one of these premiums would be given "gratis" with the purchase of $10 of any Larkin product. As the company grew, premiums could be purchased directly. In addition, this bold idea was marketed directly to average housewives on farms and in small towns, as Darwin D. Martin wrote in the Pan American Exposition edition of the monthly magazine *The Larkin Idea*. The company would tap into those "who work and struggle, all who count cost—the millions, the salt of the earth." The company's philosophy believed that those living in mansions do not count costs, and with the servants doing the ordering for the household, it created a disconnect between manufacturer and user. In addition to the Larkin Idea, the company fostered its most creative promotional engine, the clubs, to stay connected to its customers.

Around the country, regular customers were requested to become Larkin Secretaries and to start these clubs in their neighborhoods with friends and family. There were clubs of 5, 8, 10, and 16 people. At its zenith, there were 90,000 secretaries and over two million customers around the country. These clubs became a promotional force that propelled the company to even greater heights. This explosive growth is shown in a memo created in 1906 titled "Output in Pounds for Past Seven Years." In 1900, the total output was listed at 35 million pounds for 16 products. By 1906, that output more than doubled to 87 million pounds for 27 products. The company found success not only with its goods but also with the social environment these clubs created. The women of the clubs used them as a point of pride and looked forward to their monthly meetings.

Club members, led by their secretary, would each chip in for a $10 box of Larkin soap products every month. As mentioned previously, a free premium would be given with each $10 order, and therefore a premium would also be shipped. Each club member would then receive one premium a month on a rotating schedule. The success of a particular club was left to the secretary and the members to promote it to other women and create new clubs. To accommodate this growth, the companies that produced the premiums were brought under the Larkin tent. At its height, there were over 30 subsidiary companies around the East Coast. Some of the largest employers in the Buffalo area started as subsidiary companies or received seed money from the Larkin Company, such as the F.N. Burt Company, which produced boxes for shipping and packaging; Barcolo Manufacturing Company, which produced bed frames, porch furniture, and reclining chairs among other products; and Buffalo Pottery, which manufactured high-end pottery and kitchenware.

By 1903, the Larkin Company had established branches in Philadelphia, Boston, New York City, Pittsburgh, and Peoria, the last serving all states west of the Mississippi River. In 1905, the company added a branch in Cleveland. In 1908, it established a new showroom in Larkin's N building, at the corner of Seneca and Van Rensselaer Streets, to highlight some of its 1,200 products and premiums. The wealth created by the Larkin Idea led the company to the forefront of the social welfare movement for its employees. As Canisius College professor Dr. Howard R. Stanger wrote, these social welfare programs fell into three categories—"recreational, educational and financial." Larkin created a large medical department with doctors, nurses, dentists, and ample lounging and rest areas. Two employees a day were dedicated to contacting employees who were out sick and were charged with visiting the home of the infirm employees under special circumstances. A benefit association was created that paid out disability and death benefits. A lending library was created to promote good reading habits, and an in-house school was established to help employees, many of whom were newly arrived immigrants. The Larkin Company established its own YWCA for the women who worked at the plant; a dormitory on Seymour Street for women working at Larkin who were new to Buffalo; a Men's Club; an auditorium for lectures, classes, and films; a summer retreat in Athol Springs, New York, along Lake Erie; a drum corps, which traveled to competitions all over the country; a cooperative ownership program; and an employee savings program. John D. Larkin viewed his "works" as a family, one that worked hard but reaped the rewards of that ethic.

The desire for social welfare was also reflected in the buildings of the company itself, where each was created to be fireproof, with ample light, high ceilings, open spaces, and a ventilation system that pushed fresh air throughout the facilities. Nowhere, though, was the blending of the gospel of work and social welfare more evident than in Frank Lloyd Wright's Larkin Administration Building. Started in 1904 and completed in 1906, it was Wright's first commercial enterprise and was renowned for bringing the Larkin tenets of efficiency, productivity, and cooperation among its occupants to life through architecture. The chapter titles of this book come from inscriptions on the fifth-floor balcony overlooking the Central Court. The building's demolition in 1950 is representative of the collapse of the Larkin Company and is considered one of the worst blunders in American architectural history.

The high-water mark for the company came in 1920. It had 2,600 workers in Buffalo and 4,500 employees total, $23 million in sales, and over two million customers. From this date forward, the company would not maintain the prominence or the profits that it saw before. Professor Stanger identified the factors that led to the company's demise in "Failing at Retailing: The Decline of the Larkin Company, 1918–1942" for the *Journal of Historical Research in Marketing* in 2010. National branding movements began in the mid-1910s, with companies expanding their marketing to all corners of America. The Second Industrial Revolution and the advent of the assembly line allowed for the quick manufacturing of products, and companies like Ford, General Motors, Nabisco, and others made their national mark quickly. The food business was also developing, and national grocery stores such as A&P and Woolworth were spreading into communities throughout America. These companies were able to tap into the growth of the automobile, and mail order businesses like Larkin were beginning to be viewed as passé. In addition, the country was becoming more urban, in direct contrast to Larkin's view of fostering its customers in small towns and farms. Beginning with World War I, women began entering the workforce in greater numbers, a trend that did not stop when the war was over. This took the Larkin Secretaries away from the home and away from their Larkin clubs. While these external factors were exerting their forces on the company, internally the period between 1924 and 1926 was one of great upheaval. Because John D. Larkin viewed his company as family owned, he refused to bring in new blood and the new ideas that infusion could have brought. The management team of John D. Larkin, Darwin D. Martin, Harold Esty, and William Heath, all with the company for many years, either retired or died, leaving a huge hole in the institutional memory, and they were either not available or chose not to guide the newer management team comprised of Larkin's children. In 1922, a memo written by Harold Esty, John D. Larkin's son-in-law and director of advertising, shows his exasperation over the loss of Larkin Secretaries. By that year, they had lost 20,000 of the 90,000 secretaries they had just two years prior. That led him to ask what was going on and why were they bleeding that many secretaries so quickly—a question never fully answered at the time.

The company moved into other retailing ventures such as gas stations and Larkin stores. While these helped the bottom line of the Larkin Company, they were never profitable enough to bring the company back to stable ground. The company halted all soap and toiletry manufacturing in the mid-1930s and all other manufacturing in 1941. Even still, the company had so much inventory it was able to fill orders until the last—for Marie Mills, of Philadelphia—in 1962. With the sale of the R, S, T Building, also known as the Larkin Terminal Building, to Graphic Controls in 1967, the Larkin Company's footprint in Buffalo and the region's industrial base was vanquished.

One

COOPERATION, ECONOMY, INDUSTRY

HYDRAULICS

The area that has become the revived Larkinville was originally one of the earliest industrial centers in the Buffalo area. Called the Hydraulics, it was settled by pioneers as early as 1790, when Capt. William Johnson established a sawmill on Little Buffalo Creek. This creek originated near William Street, east of Babcock in the vicinity of what was to become the East Buffalo Stockyards. It crossed south at Seneca Street and Hydraulic Street and moved west below Exchange Street and into Big Buffalo Creek, today's Buffalo River. By the time the Holland Land Company began its surveys of western New York in 1798, there was Johnson's Sawmill, a few cabins, and a store/trading post operated by Cornelius Winney. When the Erie Canal was completed in 1825, the Hydraulics had the only sources for harnessing water, as there was a deep gorge at Seneca Street. The Hydraulic Association, led by Rueben B. Heacock, was established to use and manipulate the natural resources. This association created the Hydraulic Mills, including the Hydraulic Canal and Mill Race Run, which led from Little Buffalo Creek to the Main and Hamburg Canal and on to various other slips or canals like the Ohio Slip and the Clark & Skinner Canal. These canals and runs allowed goods and services to be transported by water all the way to Big Buffalo Creek and on to the Erie Canal. As technology changed, water transportation was bypassed by railroads, leading to these canals and runs being filled in by the mid- to late 1880s. John D. Larkin's company moved into the neighborhood in 1877, close enough to slaughterhouses to receive discarded fat from all of the meatpacking plants in the area.

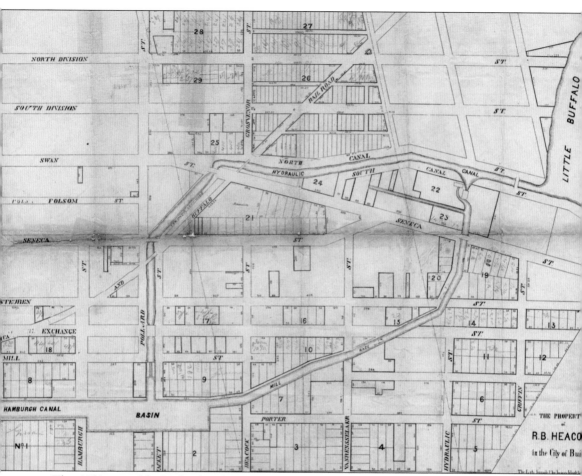

This 1850 map of the Hydraulics shows the property owned by Rueben B. Heacock, first president of the Hydraulic Association. Little Buffalo Creek can be seen at upper right, leading down to the Hydraulic Canal heading west, while Mill Race Run heads south. They both flow into the basin that leads to the Main and Hamburg Canal and heads west toward Big Buffalo Creek, Buffalo Harbor, and the Erie Canal. The Larkin Company would eventually settle on the lot at center with its familiar "point" in the northeast corner of the parcel. Cutting across the image from the top center to the lower left is the early Attica & Buffalo Railroad line. This line is still in use today, as it is connected to the CSX Transportation Frontier Yard on Broadway in Cheektowaga, New York. Twenty-seven years after this map was created, a small company whose original factory was on Chicago Street moved into the neighborhood, forever altering its landscape.

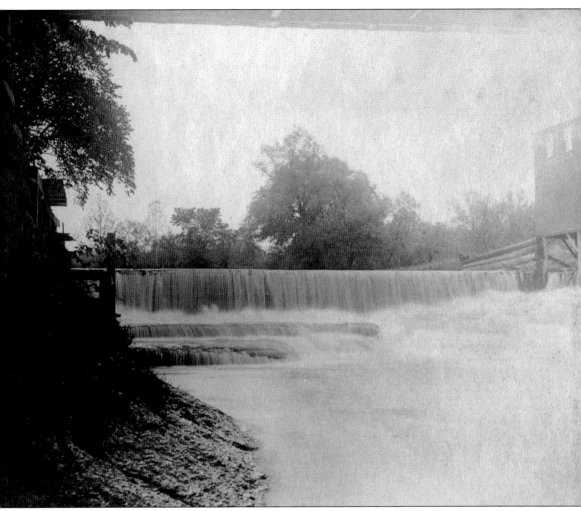

Mill Race Run was a connecting stream for Little Buffalo Creek and the Main and Hamburg Canal. When legislation was written and the Main and Hamburg Canal constructed, Mill Race Run was included. The beginning of the run was at the Hydraulic Canal at Swan Street, and it flowed south past Seneca Street. It continued gently west toward the Main and Hamburg Canal. This gave Mill Race Run direct access to Buffalo Harbor as the Main and Hamburg Canal flowed west to Main Street and the other canals in the area—the Clark & Skinner Canal, Erie Canal, and Ohio Slip and Basin. In City of Buffalo Common Council proceedings, Mill Race Run and Hydraulic Canal were first mentioned in 1833, when the cost of constructing a canal from Main Street to the Hydraulic Mills was estimated at $8,101.40. It was to be 100 feet wide with 10-foot towpaths on either side. This is an undated image of Mill Race Run. Unfortunately, it is not known which part of the run this is or what the building on the right is.

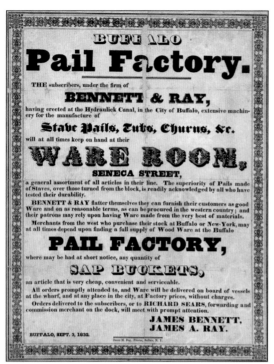

While this early broadside for a pail factory and wareroom on Seneca Street shows the firm as Bennett & Ray, the 1832 city directory lists the firm as Bennett & Kay. James Bennett was living near the corner of Seneca and Hamburg Streets, but James Ray is not listed in any of the city directories around the time. Richard Sears, listed at the bottom of this broadside, was the forwarding and commissioner merchant. Working along the waterfront, Sears would be one cog in the delivery of goods.

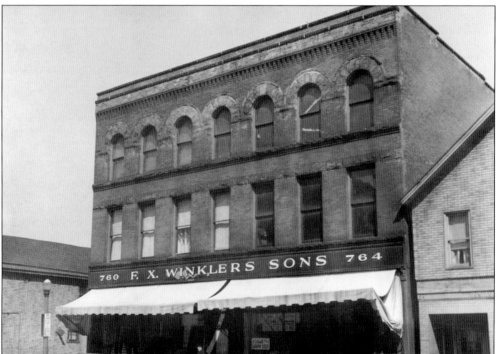

Francis Xavier Winkler opened his first grocery and goods store in 1857 at 560 Seneca Street, where he and his family resided. In 1893, they moved to 760–764 Seneca Street. Shortly after the move, the business also included a saloon. When it closed in 1968, it was Buffalo's longest running grocery and goods store. This building still stands in the Larkinville neighborhood.

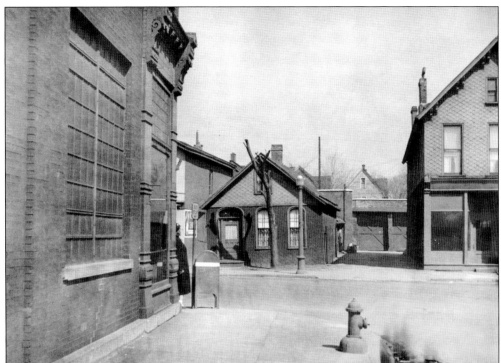

This workingman's cottage, located at 782 Seneca Street, stood where the Hydraulic Canal crossed Seneca Street heading south and west toward the Main and Hamburg Canal. The image is looking north from Hydraulic Street. At the time of the canal, John Jeckert owned the land and had built a home east of the water. This particular parcel of land constituted the canal bank.

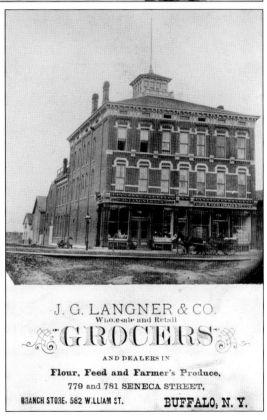

This image is looking south from the spot of the Hydraulic Canal, very close to the cottage in the previous image. The view is looking down Hydraulic Street at Seneca Street. The canal is just out of the image to the left and below ground as it crossed under Seneca Street. John Langner & Co. opened in 1868, and by 1905, Langner's sons had moved the business farther down Seneca Street. This building is still in use today, but with the third story and roof line removed and the building refaced, it is difficult to recognize.

15

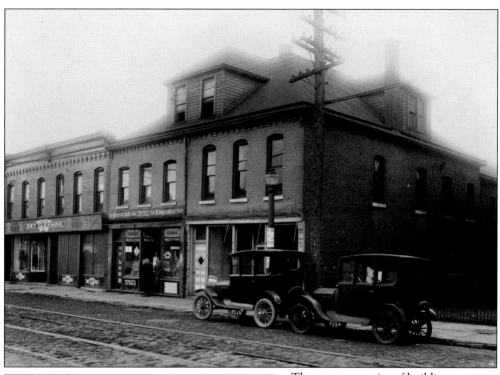

There were a series of buildings at 797–811 Seneca Street, on the south side between Hydraulic and Griffin Streets. Shown here are Dollar Co. Dry Cleaning and a general newsstand. This area is now a parking lot for the Larkinville district. It is not known when these buildings were demolished.

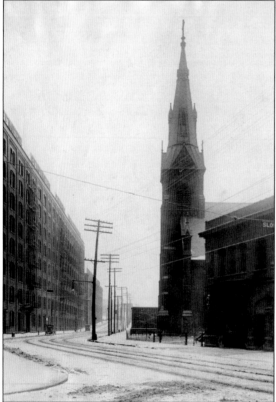

Shown is the steeple of Sacred Heart Church, located at 680 Seneca Street. The church was founded at the site in 1875 and dedicated in 1876. It moved into a new house of worship on Emslie Street in 1913 and this building was taken over by the Larkin Company at that time. The steeple was later removed, and the building became the Larkin Auditorium until 1936, when it was razed.

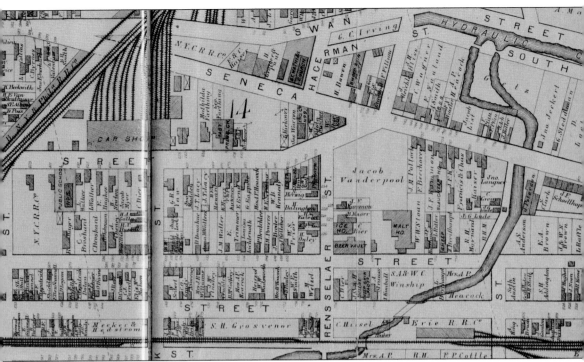

Here is another map, created in 1872, of the Hydraulic neighborhood. The Hopkins map shows buildings and land owners. The parcel that five years later was to become the home of Larkin shows 38 individual structures on it, all of which were razed as the Larkin Company grew and took over the whole parcel with its alphabetically named buildings. The map shows an excellent mix of transportation with the canals, railroads, and streets. The Erie Railroad Company is at lower right, while the Buffalo, New York & Philadelphia Railroad and New York Central Railroad are at upper left. Also shown is Carroll Street in the lower center, a street that is now closed between Louisiana Street to the west and Hydraulic Street. The large "14" became the future site of the Larkin Administration Building. On the parcel that became the Larkin Terminal Building, now the Larkin Exchange Building, the Mill Race Run Canal is shown to be flowing onsite.

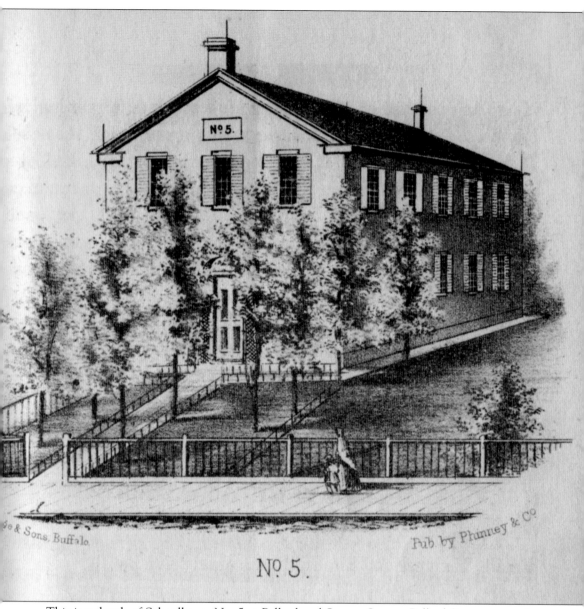

No. 5.

This is a sketch of Schoolhouse No. 5 at Pollard and Seneca Streets. Pollard Street was at the southern end of what would become Jefferson Avenue. Railroad crossings cut the street into two, and Pollard was south of the crossings. Schoolhouse No. 5 was opened as one of nine schools prior to 1839, when the school system expanded to 15. In 1838, Schoolhouse No. 5 held classes for 15 students. By 1840, it had 108 students, and by 1848, the school had classes for 555 children. The student growth is a direct testament to the growth of the Hydraulics during those years. The boundary for District No. 5 was North Division Street to the north, Main and Hamburg Canal and Perry Street to the south, the old city line at Seneca and Bailey Streets to the east, and Hamburg and Louisiana Streets to the west. In 1894, possibly due to its proximity to all of the rail yards, the school moved to the corner of Seneca and Hydraulic Streets.

Here are two images of Hook & Ladder Company No. 5 from 1905. At that time, the company was located where Van Rensselaer Street enters Seneca Street, a little east of the current firehouse. At right, members are shown holding a net used to catch people jumping out of windows to escape fire. Below, the company is dressed in its protective gear. The firehouse, called Hydraulic Engine No. IX, was originally erected near Schoolhouse No. 5 in 1846. It later moved near or next to Sacred Heart Church in the late 1870s and eventually became Hook & Ladder Company No. 5, when these pictures were taken. There is still a Buffalo Fire Department presence with Engine 32, Ladder 5 at the corner of Seneca and Swan Streets. (Both, courtesy of Nancy Gavin-Koester.)

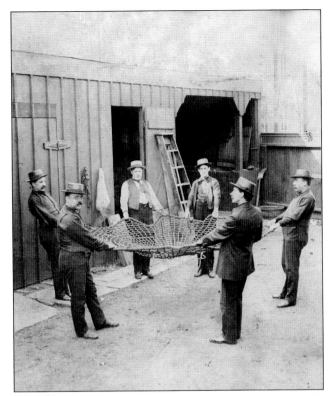

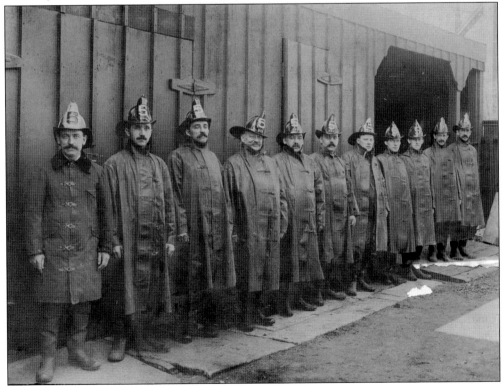

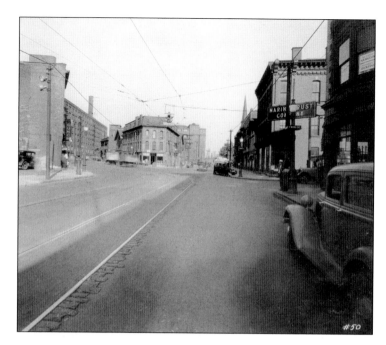

The current Engine 32, Ladder 5 stands at the spot of the three-story building at center. This photograph, taken around 1935, shows a bustling neighborhood looking west near the intersection of Seneca and Emslie Streets. At left is the familiar sight of the Larkin Company, and in the distance at center is the Larkin Administration Building.

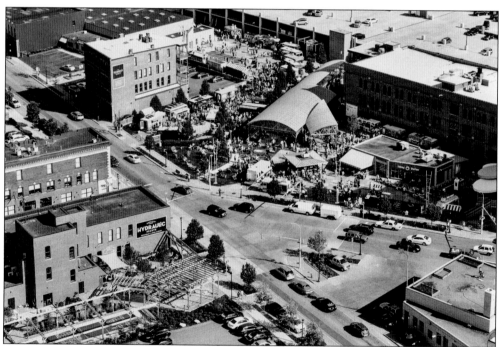

Larkin Square, a public gathering space developed in 2012 by the Larkin Development Group, is host to many events. Opened in 2013, Larkin Square hosts Food Truck Tuesdays and the Wednesday Concert Series, both of which bring thousands of attendees throughout the summer and holidays. The Larkinville and Hydraulic neighborhoods are making a comeback through diverse investments, multiuse spaces, and strong partnerships. (Courtesy of the Larkin Development Group.)

Two

IMAGINATION, JUDGMENT, INITIATIVE

ORIGIN

John D. Larkin was born at 13 Clinton Street in Buffalo to Levi and Mary Larkin. Both parents were industrious and were looking to stake their claim in a new, growing city. Levi, who apprenticed as an ironworker in England, got his start in Buffalo with George Jones and then went on to open his own business, which he ran out of the family home. In 1845, John was born, the fourth of seven children. Levi, who was also part of Buffalo's volunteer fire department with Eagle Hose, died from complications battling a fire when John was seven years old. John and the family had to grow up quickly, which John embraced with vigor. His older sister Mary had wed a soap maker named Justus Weller, who owned his own business. After John became a partner, the company moved to Chicago to continue expanding the business. Two things happened in Chicago that changed John's life. He witnessed the devastation of the Chicago fire of 1871 and met the Hubbards. John's empathy for those who were lost in the fire and for those businesses destroyed was palpable. He vowed if he ever opened his own company, he would treat the employees to the best safety practices of the day. Meeting the Hubbards must have been an exciting prospect. Dr. Silas Hubbard, the patriarch of the family, was a leading member of the Buffalo medical community for a time. John also met Frances, or "Frank," Dr. Hubbard's daughter. He was taken with her, and letters between them show John embraced his affections openly, while Frances may have been more cautious. After successfully sharing wedding vows, John dissolved his partnership with Weller after Weller made a string of bad business decisions and ultimately decided to move back to Buffalo. With his new wife beside him, John set out to start his own soap-making business.

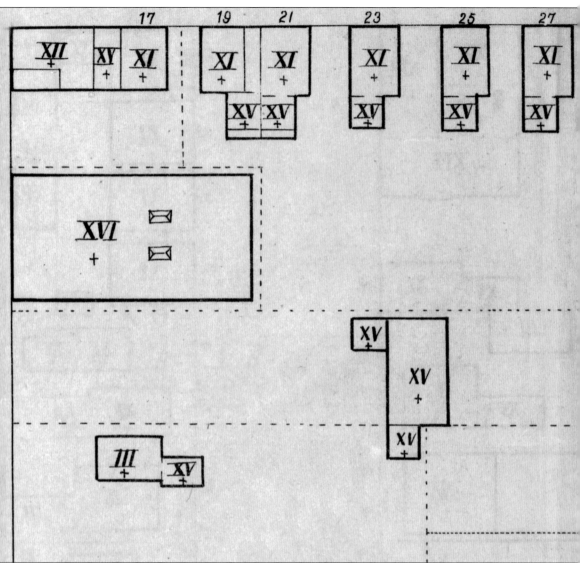

Here is an 1854 Quackenboss & Kennedy map showing the birthplace of John D. Larkin in the upper left corner. The address of 13 Clinton Street is not labeled on this map, but it is listed with the Roman numeral "XII," a frame dwelling with a partial storefront. John D. Larkin's father, Levi, opened an ironworks business called Clinton Iron Works and worked out of his home. This is the southeastern corner of Clinton and Ellicott Streets, currently a parking lot across from the Lafayette Hotel. Also a firefighter, Levi caught pneumonia and died at the young age of 35, leaving his wife to tend to seven children. The widow and children moved shortly after Levi's death to 203 Oak Street and rented out this house and storefront.

Greenpoint April 15th 1865

Inventory of Property owned by Larkin & Weller

One Horse	171	✓
" Wagon and Frame	109.75	✓
" Harness	27	✓
Two Pails	7	✓
One Dipper	2.75	✓
Steam Pipes	10.69	
One ?	328.19	✓

The index above, written in John Larkin's hand, is titled "Inventory of Property owned by Larkin & Weller, April 15, 1865." Larkin was a traveling salesman for the company at that time and wrote the inventory in his ledger while in the Greenpoint neighborhood of Brooklyn. Included are one horse, wagon and frame, harness, two pails, one dipper, and a steam pipe for a total of $328.19 in assets. The pails, dipper, and steam pipe are basic products used for soap making, but it is not clear whether Larkin was making soap while traveling. It could be that he purchased the materials to take with him to the Larkin & Weller factory. At right is a list of purchases and withdrawals of John D. Larkin while traveling with the Larkin & Weller Company in 1872. It shows purchases of shoes, coats, vests, pants, medicine, and haircuts.

Chicago, Nov 8th 187_

Frank

Perhaps I am imposing upon your Good nature and Patience in this addressing you — but would not feel justified in dropping this subject without a better understanding between us. What passed between us Thursday Evening — was — on my Part — intended as a "Bona Fide" offer of Marriage. and I thought you would so understand it — though you apparently made light of it — perhaps — my Manner was too "Matter of Fact" or — too "Business like" and unromantic to become such an Occasion. but nevertheless I

"What passed between us Thursday Evening was—on my part—intended as a 'Bona Fide' offer of marriage" This letter from John D. Larkin to Frances "Frank" Hubbard on November 8, 1873, stands as a testament to his interest to marry her. The couple met through Larkin's business partner, who was a cousin of the Hubbard family. The Hubbards visited Justus Weller in Chicago often, and it was on one of these visits that John met Frances.

Here is a stylized image of the building at 196–198 Chicago Street, where Larkin opened his first factory after he moved back to Buffalo. He leased this property from the Holmes brothers, who also had a large planing mill and ironworks company located at 55 Chicago Street and 187 Michigan Street. "J.D. Larkin: Manufacturer of Plain and Fancy Soaps" worked out of this 3,000-square-foot factory for two years before needing to expand.

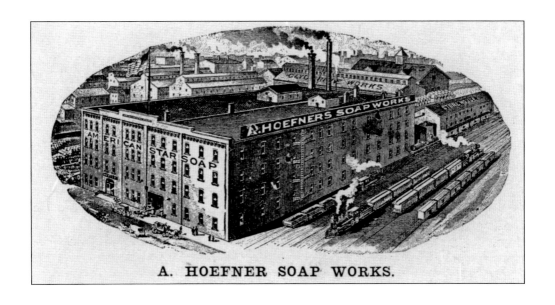

A. HOEFNER SOAP WORKS.

At the time Larkin was establishing his business, there were already three large soap makers in Buffalo. The Anslem Hoefner Soap Works Company, shown above, was located on Van Rensselaer Street beginning in 1864. The company, which produced soap, candles, and potash (a potassium mineral) lasted from 1864 to 1930. The image below shows the Lautz Brothers & Company, located at Hanover and Prime Streets in what is now Canalside. This company opened in 1865 and closed in 1922. Another large company was the R.W. Bell Soap Manufacturing Company, located at 78–80 Washington Street, which remained open until 1893. Two of these companies closed at the beginning of the Larkin Company's decline, evidence that national trends in marketing, selling, and distribution were affecting many businesses.

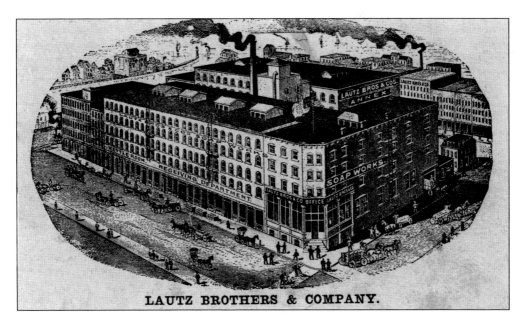

LAUTZ BROTHERS & COMPANY.

Buffalo N.Y. April 1st 1878.

In consideration of and for a note bearing even date herewith drawn by E.G. Hubbard for the sum of Twenty Eight hundred ninety two & 51/100 dollars Payable to J.D. Larkin in Four semi-annual payments— the said J.D. Larkin sells transfers & assigns to the said E.G. Hubbard— for the purpose of enabling him to hold One Third of the Capital Stock of the firm of J.D. Larkin & Co— the following property to wit:

250 lbs Harness soap scrap	15.00
5012 doz "Oat Meal" soap in frames	1002.40
3530 doz "Oat Meal" soap on racks	751.89
150 Gross "Oat Meal" soap at Rochester Rkgs	473.80
150 Gross "Oat Meal" soap at Cincinnati	450.00
2274 lbs Oat Meal cuttings	105.06
365 doz damaged toilet	54.75
110 doz "Brown Glyc" soap	39.60
	$2892.50

And it is further understood and agreed by the said parties hereto that in case the said firm of J.D. Larkin & Co shall be dissolved previous to the full settlement of said note the said E.G. Hubbard will take up settle and fully pay said note together with any and all interest thereon that may remain unpaid at time of such dissolution.

J.D. Larkin
E.G. Hubbard

Shown is an agreement between John D. Larkin and his brother-in-law Elbert Hubbard on April 1, 1878. It states that Hubbard would pay Larkin four semiannual payments of $2,892 for transfers and holdings of one third of company stock. This agreement lasted until 1893, when Hubbard left the company to focus on his writing and to formulate his interest in the arts and crafts movement. The subsequent arrangements for sale of Hubbard's stocks back to the Larkin Company created a rift between the brothers in law that was never fully reconciled. Through five years of suits and countersuits, Larkin and Hubbard finally settled their dispute in 1897, free to go their own ways. What started out as an innovative manufacturing team based on family ties had been hurt by professional and personal decisions. This led John D. Larkin to make the assessment to keep the management of the Larkin Company in his immediate family, a choice that would have harsh consequences as the company continued to grow.

Here is John D. Larkin in 1880. At this point, he had spent about 10 years working for his brother-in-law Justus Weller in both Buffalo and Chicago, courted and married Frances "Frank" Hubbard, moved back to Buffalo and opened his own company, and had four young children at home. The 1880s would become a decade of explosive growth and innovation that would propel the company for another 40 strong, profitable years.

In this undated photograph of Elbert Hubbard, the creative genius of the Larkin Company can be seen. He decided to join John Larkin and his older sister, Frances, when John was opening his business back in Buffalo. He traveled around the country distributing soap to wholesalers and grocers and providing direct sales to women in the home. He was killed with his second wife, Alice, when the ocean liner *Lusitania* was struck by a German torpedo and sunk in 1915.

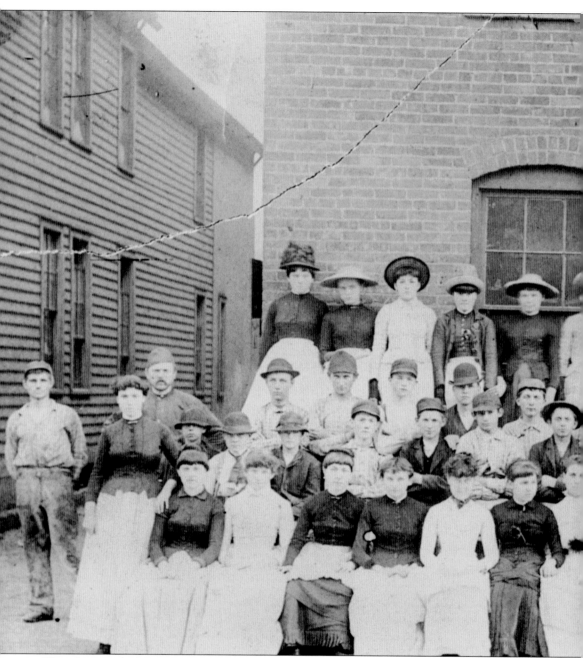

This photograph shows the Larkin employees in 1883. They are standing in front of some of the original buildings at the Seneca Street location, before any of the structures standing today had been constructed. Most of the employees appear to be teenagers. Three individuals stand out. Darwin D. Martin, second from right, was one of the guiding forces of the company. He joined the Larkin Company as John's office bookkeeper when he was 13 years old in 1879. After Elbert

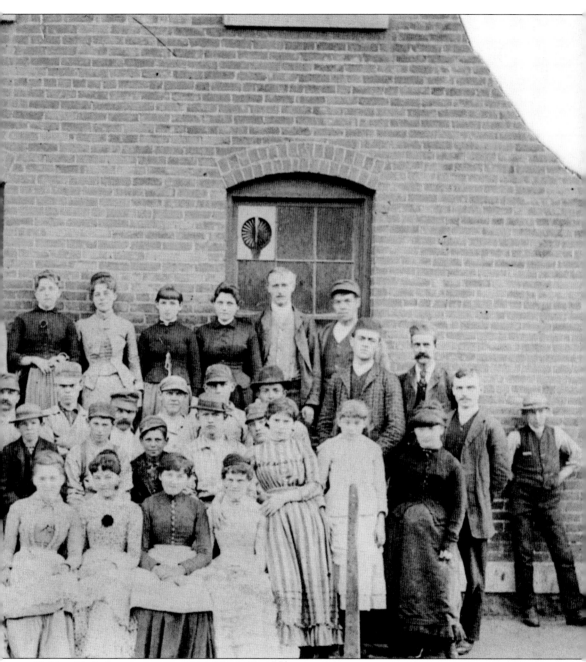

Hubbard left the company in 1893, Martin became one of the most important employees, guiding the company through its years of growth. Also shown are the Coss brothers, Daniel and William, also on the right. The brothers were from Philadelphia and joined the company in 1880, remaining until 1909. William rose to become the superintendent of the factory, while Daniel became the head of shipping and receiving.

OUR GREAT COMBINATION BOX.

Remember, the cost to you is but half the retail prices, which we name only to clearly show how much we save you.

100 Bars "SWEET HOME" Family Soap, $5.00
Enough to last an average family one full year. This Soap is made for all laundry and household purposes, and has no superior.

10 Bars White Woolen Soap .70
A Perfect soap for flannels.

9 Packages Boraxine Soap Powder (full pounds), .90

¼ Doz. Modjeska Complexion Soap .60
Perfume matchless. For all toilet purposes it is the luxury of luxuries. Especially adapted for the nursery or children's use, or those whose skin is delicate.

¼ Doz. Elite Toilet Soap, Very Fragrant .25

¼ Doz. Old English Castile (six ounce cakes) .30
A pure milled Castile Soap. Superior to ordinary Castile. Made from pure Olive Oil.

¼ Doz. Creme Oatmeal Toilet Soap, Scented. .25

¼ Doz. Sulphur Soap .45
The antiseptic qualities of Sulphur baths promote the general health; remove Hives, Prickly Heat, or other eruptions.

¼ Doz. Larkin's Tar Soap .45
Infallible Preventive of Dandruff, Baldness, Clogged Pores, and Oily Skin. Unequalled for washing the hair.

One Bottle (one ounce) **Modjeska Perfume** .30
A delicate, refined, delicious perfume for the handkerchief and clothing. The most popular and lasting perfume ever made.

One Jar (one ounce) **Modjeska Cold Cream** .25
A most delightfully pleasant, soothing, healing, and agreeable demulcent. A perfect emollient. For Chapped Hands, Lips, or Inflamed Eyelids, a sure and speedy cure.

One Vial (two ounces) **Modjeska Tooth Powder,** .25
An incomparable dentifrice, giving beauty and whiteness to the teeth, preserving them, and invigorating the gums. Purifies the breath.

One Packet Spanish Rose Sachet Powder .20

One Stick Napoleon Shaving Soap .10

The contents, if Bought of Retail Dealer, actually costs $10.00
Your choice of Premiums, either are worth ten dollars at retail 10.00

All for $10.00. (YOU GET THE PREMIUM GRATIS.) $20.00

YOU SAVE HALF THE RETAIL PRICES, besides the inestimable satisfaction of using only the BEST and PUREST Goods.

Here is an advertisement for the first incarnation of the Larkin Idea called the Combination Box, which consisted of $6 worth of products along with gifts. The customer was given 30 days to pay for the products, which the Larkin Company saw as a pact between the factory and the family, a bond that would be fostered throughout the life of the company. A few years later, a $10 Combination Box was created; included with it was a certificate for a free premium, a household product. While the $6 box held free gifts for children and other adults in the home, the $10 box included a much wider array of products, marketed as "$20.00 of retail value for $10.00." Looking at premium lists from the early 1900s, customers could choose from products such as the Chautauqua desks, Chautauqua recliners and rocking chairs, mantel clocks, sewing desks, tea sets, silverware sets, cribs and bed frames, mattresses, lamps, stoves, and other products for the home. This idea took off, and the company was selling upwards of 91,000 Combination Boxes a year.

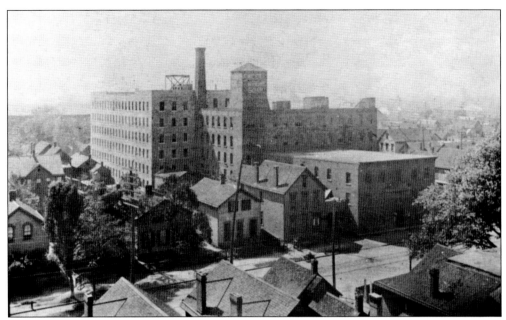

These two images show the original Larkin buildings at the corner of Seneca and Heacock (later Larkin) Street. The above image shows the factory from a building rooftop near Swan Street, one street to the north. In the foreground is Seneca Street and some of the housing that was on the block before the Larkin factories expanded to include this whole lot. It appears as though the lighter brick structure toward the back is Building C under construction. The two buildings facing Seneca Street were taken down in 1899 or 1900 for construction of Building H. In both images, Sweet Home Soap and Boraxine, the first two laundry soap products made, are being advertised. These were the first buildings constructed when Larkin moved from Chicago Street in 1877, but even these were insufficient to manage the growth of orders and products by 1900. The image below also appears to be from Swan Street but was taken closer to the ground, probably on the roof of a home.

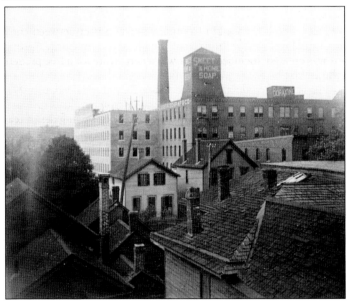

3/13/01.

THE LARKIN IDEA:
"Save all cost which adds no value"

is proposed by Miss Dale, Mass. Group. If anyone thinks it is not better than
"Save all cost which does not add to value;"
"Save all cost which does not add value" or
"Save all cost which adds nothing to value"
will they please write on mem the form they prefer and send to Mr. Martin?

D. D. M.

Here is a memo from March 3, 1901, discussing a tagline for the Larkin Idea. "Save all cost which adds no value" was proposed by a Miss Dale from the Massachusetts group, and the memo is comparing it to other taglines. It asked the employees to rate it against the other lines and to submit their choices to Darwin D. Martin. Larkin sales and accounting department employees were broken up into different divisions based on sales and orders from states around the eastern portion of the country. For example, there was a team that handled orders from Virginia or New Hampshire or Pennsylvania. The company received thousands of orders a day, and this division of labor allowed the company to keep track of each individual order from reception to shipping. Miss Dale worked in the Massachusetts group handling orders from that state. This tagline became a ubiquitous marketing line used on many catalogs and premium lists after it was chosen.

Pictured is the aftermath of an explosion in the second Larkin factory. This side of the building is facing south toward Steuben Street, the original name for what is now Carroll Street. Here, the by-product from the process to create Sweet Home Soap has run down the side of the building, while presumably, a Larkin employee poses in the foreground.

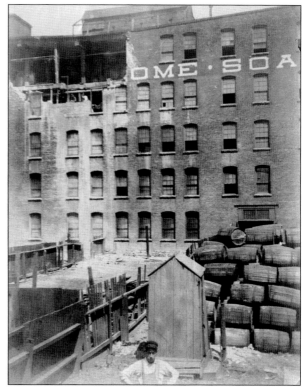

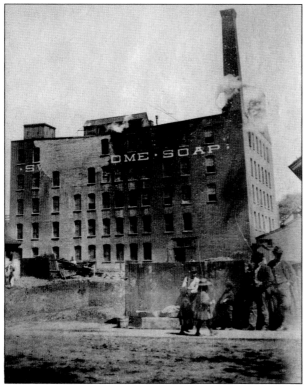

Here is an image that captures the repair of the explosion. The whole south side of the building is seen facing Steuben Street, while kids play in the foreground. Two employees are also hanging out the window above the letter "S" in "Soap." The two images on this page show the back of the building with the chimney (see page 31). The images on page 31 show Building C under construction, while these two show the land before construction started.

33

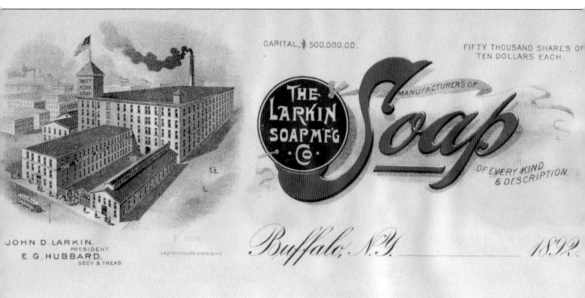

Pictured is Larkin letterhead from 1892, showing John D. Larkin as president and Elbert G. Hubbard as secretary and treasurer. The company went through various names throughout its existence but was known as the Larkin Company from 1904 onwards. In 1892, it was called the Larkin Soap Manufacturing Company, but as the list of other products and premiums grew, the word "soap" was eventually removed from its name. This letterhead shows etchings of the buildings that are seen on page 31. The letterhead also lists the company having a capital investment of $500,000 by selling 50,000 shares of $10 each to loyal customers. A premium product was given for free with a purchase of a share. Much of the company's profits at this time came from the selling of the Combination Box. At Christmastime, the company expanded on the box in what was called the Mammoth Combination Box, which included various gifts and trinkets for children.

COFFEE SPOONS. 11/18/00.

We have been asked why the Company does not furnish spoons with the coffee. This is why: On December 1st, 1899, 180 spoons were put into the coffee equipment. To-day the office owns six tea spoons. We do not furnish spoons because the spoons are all gone.

Larkin Soap Co.

These two images are from an interoffice memo book that was kept by a Larkin employee. It is currently on display at the Larkin Gallery on the first floor at 701 Seneca Street. The interoffice memos from 1899 to 1903 give a fascinating insight into the corporate culture and complexity of the company at this time of quick growth. While the Larkin Company was known for its social engagement and welfare programs for employees, it was not without its desire for an orderly workplace, as evidenced by these two memos. The image above gives a funny insight into missing spoons that were given with coffee, and the image below shows a memo asking employees to keep quiet during business hours and to remember, "At all hours some are engaged at work." (Both, courtesy of Sharon Osgood.)

ALL CONVERSATION

POSITIVELY FORBIDDEN

During business hours, except such as pertains directly to the business.

Nearly every message or inquiry that one clerk may have for another can be better conveyed in writing. It avoids misunderstandings and prevents interruptions.

All should remember that at all hours some are engaged at work, and avoid in the office, loud conversation or laughter before, between or after regular business hours.

10/15/00.

The line under-scored is often forgotten. There is too much noise between 8 A.M. and during noon hour, at both of which times the In-Mail force is endeavoring to concentrate attention upon their work.

Larkin Soap Co.

Jan,5'1900.

Following is a complete list to date of the various Departments and Sub Departments in the General Offices, together with their official abbreviation.
Address all papers to any Department, with its abbreviation.
Always sign your initials in addition to the abbreviation for your Dept.
Division Clerks will use their Division name.

A.I.	Ack.Dep.Inquiries.	I-M.	In-Mail.
A.N.O.	" Note Orders.	I.Cor.	Inquiry Correspondents.
A.O.E.	" Odds & Ends,	L.D.	Legal Dept.
A.P.P.	" P.P.Orders.	L.R.H.	" Mr.Heath,
A.R.	" Remittances.	L.Cor.	" Legal Cor.
Adv.	Advertising Dept.	P.D.C.	" Past Due Cor.
Amb.	Amberg File,	P.D.Cl.	" Past Due Clerks.
Amb.I.	" Inquiries.	D.D.M.	Mr. Martin.
B/L.	Bill of Lading File,	Mim.	Mimeograph.
Blue	Blue File,	O.M.	Office Mail,
Bk.	Bookkeeper, General,	O.D.	Order Dept.
Bdl.C.	Bundle, Common,	O.D.C.	Order Dept. Cor.
Bdl.R.	Bundle, Remittance,	O.Tr.	Order Tracers,
Crt.C.	Certificate Complaints.	O.O.F.	Original Order File,
C.S.	City Sales.	Fwo.	" Fwo.
C.P.	Club Premium,	Ac.Or.	" Ac.Order.
C.P.Com.	" Complaints,	O.M.	Out-Mail,
Crt.R.	Certs. Redeemed.	Pay	Pay Dept.
Cr.	Credit Dept.	Prt.	Printing Supplies.
C.S.R.	" S.R.Orders,	Red	Red File,
Cr.F.	" Forms,	R.G.	Returned Goods,
D.Cor.	Division Correspondents.	R.M.	" Mail,
D.C.F.	Division Cor. File,	R.D.	Routing Dept.
Divisions	Use Division Name.	S.O.	Shipping Office,
Dray	Dray Dept.	Store	Store Room,
E.R.	Error Record Dept.	Tr.	Transfers.
F.T.D.	Freight Traffic Department.	Trbl.	Trouble.
G.P.	General Paids,	T/W.O.	Typewriter Ord.Dept.Forms.
Hfi.	File for Orders held for informn.	T/W.C.	" Complaint, Cert."
H.Cab.	Holding Cabinet.		
H.B.	Home Bites.	U.L.	Unsigned Letters.
		Wrk.	Workshop.

Larkin Soap Co.

Another interoffice memo from the same book presents a listing of departments and sub-departments as of January 5, 1900. There were 51 departments and offices, each with its own record-keeping system to keep track of orders, payments, and shipments of goods. For example, the "Amber File" (Amb.) contained letters received and copies of letters written that did not relate directly to the prospective or past sale to a customer. The "General Paids" (GP) were cards that were delivered to a team clerk based on state of origin. The team clerk alphabetized the cards by state and delivered them to the division clerk, who filed all the cards into a GP filing system. The complexity of record keeping for the Larkin Company led Darwin D. Martin to establish the Larkin Card Indexes in 1885 and do away with large, bound ledger volumes. This allowed accounts paid to be posted right onto the card, and each customer's data was readily attainable through this system. (Courtesy of Sharon Osgood.)

Three

IDEAS,
EMOTIONS, INVENTIONS
THE "WORKS"

From 1875 to 1885, John Larkin, now working with his wife's brother Elbert Hubbard, had by all rights a successful business. They had markets in every state east of the Rocky Mountains and were expanding, as evidenced by the need to move from Chicago Street to the Hydraulic neighborhood within two years of opening. Hubbard, as a traveling salesman, noticed he was selling many products directly to housewives in their homes and came up with the Larkin Idea. The idea of direct mail order was not new, having been successfully incorporated at Sears, Roebuck & Company and Montgomery Ward & Company. With the creation of the $6 Combination Box and later the $10 Combination Box, the Larkin Company was selling as many as 91,000 per year. When the Combination Boxes were phased out to fully embrace the Larkin Product and Premium List, the company created its clubs. These personified the "Factory to Family" motto and engaged loyal customers in ways not fully realized by other mail order businesses. During Larkin's peak years, the policy of $10 of merchandise for a free $10 premium was fully implemented and embraced. Orders were arriving so quickly that subsidiary companies were created or incubated solely on the back of these Larkin orders. Factories to produce china or kitchenware, desks, onyx tables and lamps, heaters and cookers, clocks, bookcases, reclining rockers, and glassware were coming under the Larkin banner. At the peak, there were 30 known subsidiary companies. Also fueled by this growth were the establishment of various branches and showrooms in major cities around the Northeast. While Larkin's products and its delivery model targeted small towns and farms, big cities were not neglected. The company's profits soared from the mid-1880s through 1920, when its prestige and profits began to decline.

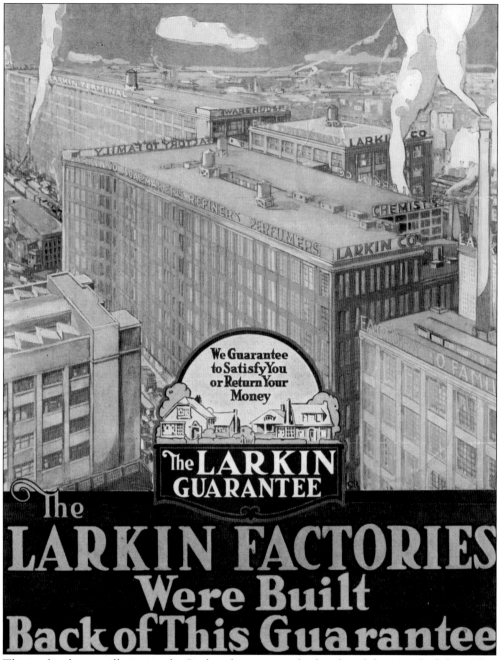

This stylized cover illustrates the Larkin factories at the height of their profitability. This advertisement shows the Larkin Administration Building, Building I (the powerhouse), the Larkin Terminal Building, Building P, and the main factory. The guarantee written on the cover was another Larkin promise to create goodwill and a connection with its consumers. Its intent was to show that the factories were thriving because of the promise that the company kept to its consumers, over two million in all. What started with the Combination Box and its policy of being offered free on 30 days notice was the belief that a company that treats its employees and customers well will earn their trust and keep them coming back.

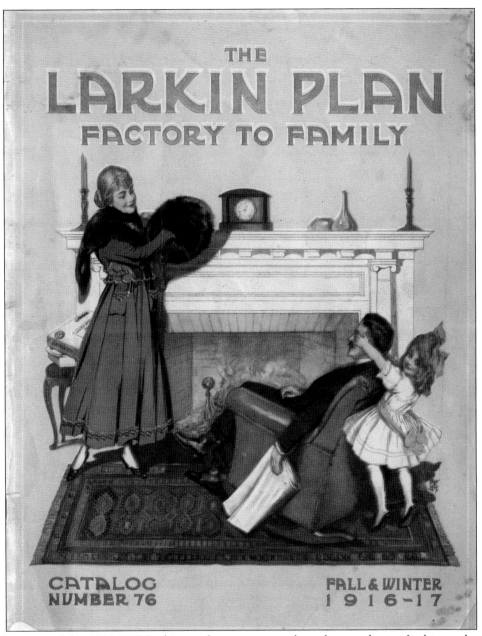

THE

LARKIN PLAN
FACTORY TO FAMILY

CATALOG
NUMBER 76

FALL & WINTER
1916-17

The cover of this 1916–1917 Larkin catalog attempts to show that purchasing Larkin products would allow customers to furnish their homes through premiums and other items received for free when purchasing $10 of soap and toilet products. By 1880, the company was advertising in very traditional ways, through newspapers, bulletins, and receiving names of potential buyers from current customers. The product lists that were published became the Product and Premium List and eventually the Larkin Plan of Factory to Family in 1912–1913. The first few pages of the catalog were dedicated to "The Larkin Plan of Factory to Family Dealing," which explained how to order Larkin products and premiums. It also gave a description of the Larkin clubs set up around the country and a map showing which office to send orders to based on customer location. This edition also had 138 pages of Larkin products and premiums.

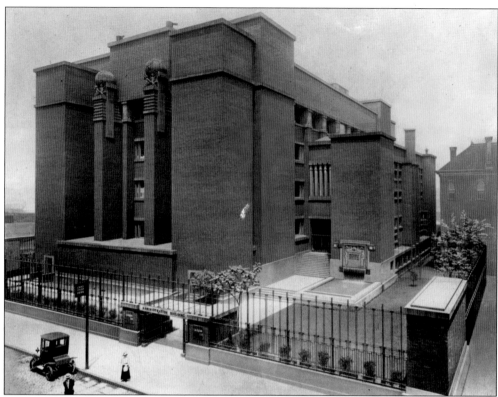

The Larkin Administration Building, constructed from 1904 to 1906, is what one visitor called a "Temple to Labor." H.P. Berlage, an architect in Amsterdam, Holland, described the building by saying, "Whatever conception of the commercial building we may have here in Europe, nothing exists of such power as this American building." These two images show that power. Above, the exterior of the building from Seneca Street can be seen, with the entranceway and its welcoming waterfall at right in the annex. Below is a detail of the entranceway, the waterfall, and one of the many tablets that have phrases celebrating work ethic, harmony, and community. The tablet reads, "Honest labor needs no master, Simple justice needs no slave." This building was the culmination of the partnership between Darwin D. Martin and Frank Lloyd Wright. At the company's height of production, it housed 1,200 office workers.

Upwards of 60,000 visitors a year came through the doors of the Larkin Administration Building and the factories. As a marketing tool, the Larkin Company was constantly inviting customers to Buffalo to see "The Falls" and visit the factory. Here, a group of visitors has received the tour of the Larkin Administration Building and is now ready to move to the factory floors.

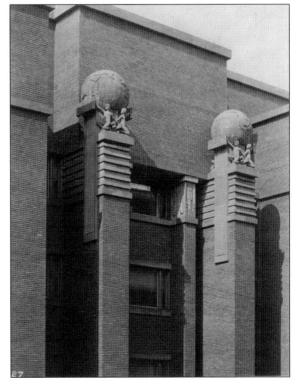

The pier sculptures that adorned the Seneca Street facade are seen here. Conceived by Frank Lloyd Wright and sculptor Richard Bock, these cherub-like figures hold up large scrolls reading "Larkin." These columns were part of a system that let fresh air into the main floors of the building.

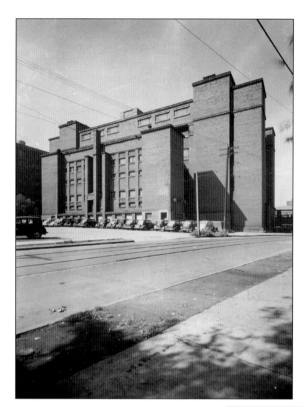

Pictured are the eastern and partial northern facade at Swan Street. The only remaining part of this building is the northwestern pier of the fence that surrounded the building. Today, it can be seen down Swan Street, where this photograph was taken. Shown is the annex to the building and the north entranceway, partially hidden in the shadows of the annex itself.

This street-level image of the south facade of the Larkin Administration Building at Seneca Street shows the fencing, which literally and physically separated it from the rest of the Larkin complex. When planning the building, Wright looked to incorporate a clean and functioning office space while making it as conducive to business as possible.

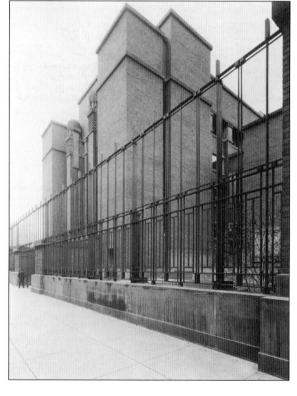

Shown here in 1939 is the same south facade facing Seneca Street. By this time, the pier sculptures had been removed, while windows, not in the original design, were cut into the fifth story, as evidenced here. During the declining years of the company, the building was converted into other uses, and a Larkin department store moved into the first three floors of the building in 1939.

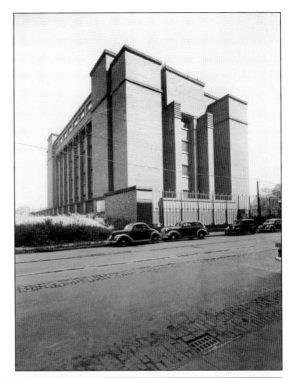

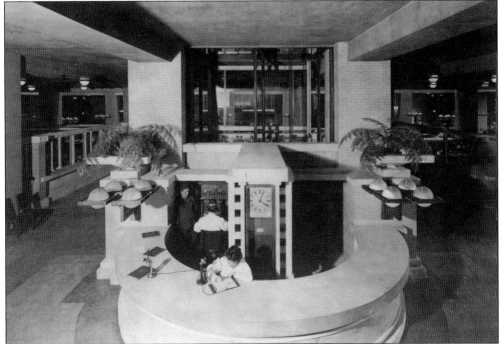

Once visitors entered through the Seneca Street steps into the annex, they were greeted in the reception area. It had a curved reception desk and an elevator shaft behind the desk. Walking past the desk, one would arrive at the main central court area on the first floor, while across from the desk was a fireplace and a small visitors balcony, where this photograph was taken.

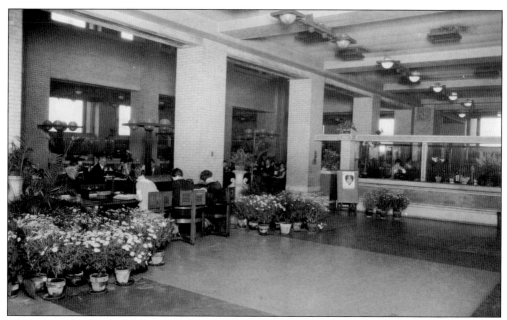

This appears to be the lobby area immediately west of the reception desk shown on the previous page. According to blueprints of the first floor from 1906, the only open space is this area behind reception. Original plans do not show desks here, but there seems to be a "Have a Heart" flower drive being conducted, thus calling for desks. The women could be volunteering to organize the flower sale.

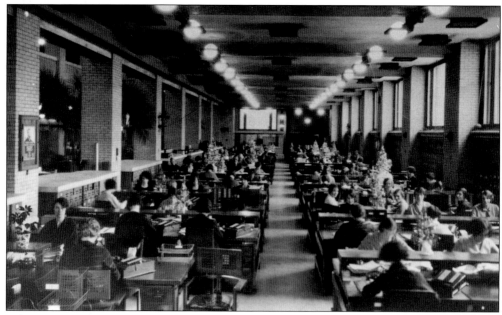

This view of the west side of the first floor shows mail order group A, one of the departmental groupings based on states. Mail would arrive and be moved to the third floor for sorting. Once sorted, it moved to its prospective state department for the first "touch" on the order. In keeping with workflow harmony, most of the mail flowed downward to lower floors. This would be the view from roughly Darwin D. Martin's office.

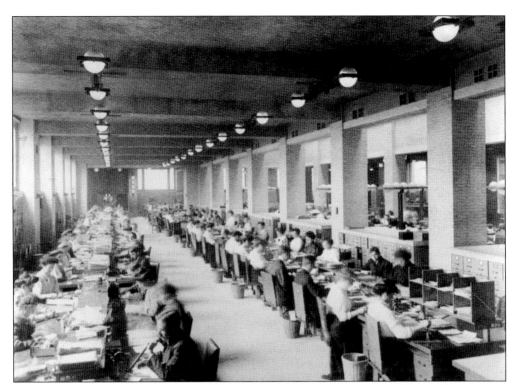

Here is another view of the west side of the first floor showing mail order group A. This is an earlier photograph than the previous one; the arrangement of the office furniture is different. This picture was taken from the south end of the building looking north. The previous image was from the north looking south.

This is a well known photograph of the Larkin Administration Building. It shows a fully lit central court, which Frank Lloyd Wright mimicked from other buildings in America, notably the Peabody Institute Library in Baltimore, and the Marshall Field Store in Chicago. The Larkinites in this section of the building primary worked to maintain the biannual catalog and premium lists.

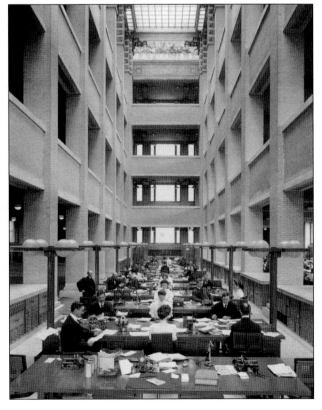

Pictured is a narrow balcony on the east side of the building that overlooked the reception desk (page 43). This area was reserved for visitors to write notes to the Larkin Company after their tours. There is ample light at each writing desk, and it can be imagined that after the tour of the factories, it would have been a relaxing, quiet place for reflection.

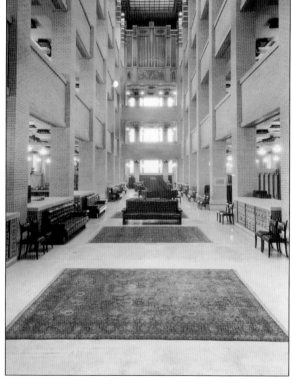

As the Larkin Company was nearing the end and mail order business was becoming less of the company's overall profit, the central court of the Larkin Administration Building became a place for recreation. In this 1934 photograph, the pipes of the Moehler organ can be seen, installed in 1925 and occupying the fourth and fifth balconies overlooking the central court. There is also much less office furniture than in earlier photographs.

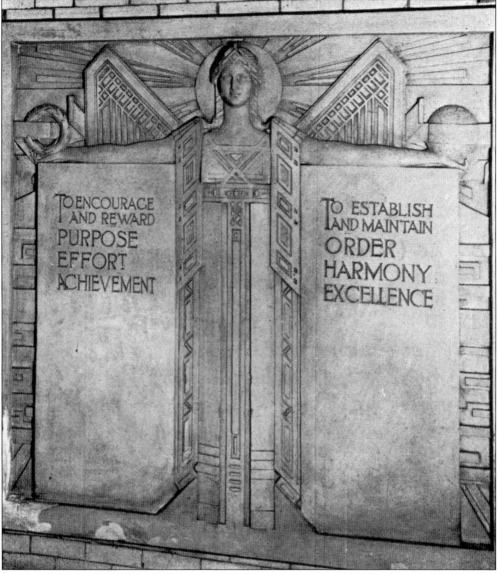

The well-known Aurora Panel adorned the lobby on the eastern wall of the annex. Frank Lloyd Wright originally planned for three panels, but adding a fireplace took the number of panels down to two. This is the only known photograph of the relief panels. The companion panel, of which no photograph exists, read, "To acquire and cherish Humanity, Knowledge, Strength" and "To inspire and diffuse Ideas, Emotions, Inventions." These panels continue the theme found on other parts of the building that celebrated global community, virtues of work, and Larkin's place within it. Here, the woman figure is holding a wreath in her right hand and a globe in the other. The figure on the companion panels held a book in one hand and a lamp in the other.

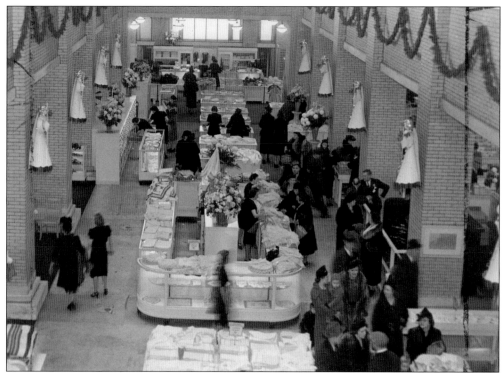

These two images from the late 1930s show the Larkin Administration Building after the first three floors were converted into the flagship department store. The original department store, constructed in 1908 across the street on the first floor in the Seneca Street factories, was moved to the administration building, while all workers in this building were shifted to the fourth and fifth floors. The restaurant occupying the fifth floor had already been consolidated in 1920 with the factory restaurant, which gave ample room for the move. The above photograph shows the department store in the central court during Christmastime, while the image below shows another angle of the converted central court.

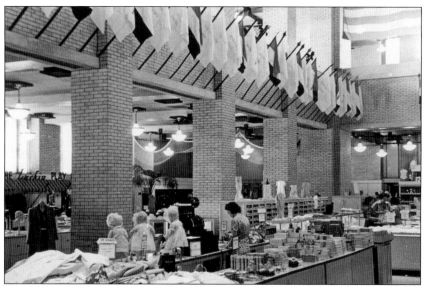

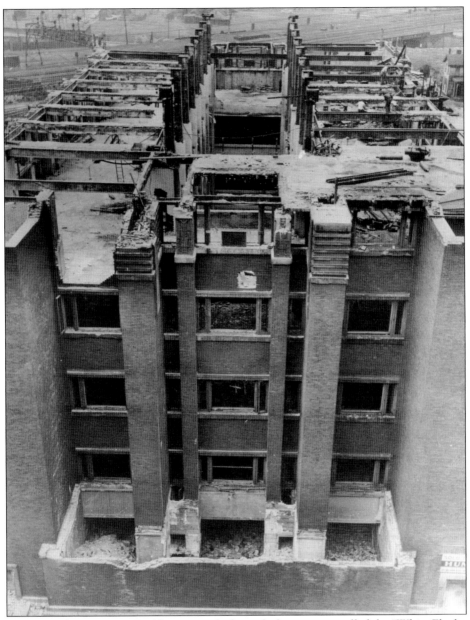

The Larkin Administration Building, towards the end of its use, was called the "White Elephant" by all of the newspapers in town. By 1943, the building was sold, along with half of the business, now called Larkin Co. Inc., to a developer from Pennsylvania, who abandoned the building when federal tax breaks did not materialize. The City of Buffalo took it over in 1945 and looked for other buyers; the building was left vacant and open to vandals. After four years of looking for a potential purchaser and seeing resolutions to convert it to a recreational center and other uses struck down by the Buffalo Common Council, this world-renowned masterpiece of commercial architecture was sold for $5,000 to Western Trading Corporation. In February 1950, the dismantlement of the building began. In this image, the roof and the fifth floor are seen during early stages of demolition. Newspapers like the *New York Times* and the *New York Herald Tribune* decried the loss. To this day it remains, as a *Buffalo Evening News* article from April 1949 states, "A Shame of our City."

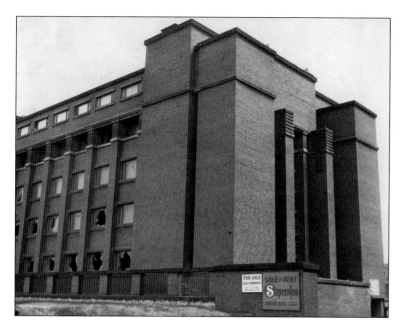

Pictured is the vacant building. Broken windows and "For Sale" signs are clearly evident. Because of the building's unique design, the demolition had to be completed by hand and practically brick by brick. It cost the demolition firm Morris & Reimann almost $55,000 to see the project through.

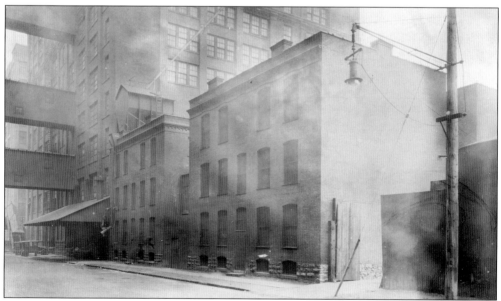

Pictured here are two of the eight smaller structures that constituted the Q buildings. This view, taken from Carroll Street, shows the three walkways from Building O to Building P. By the late 1920s, these two building were demolished and the rest of the six structures contained storage tanks, varnishes, metal vats, and paint.

The Seneca Street factory is a collection of 12 disparate buildings. This view shows the first-story department store that eventually moved into the Larkin Administration Building. Currently, this first floor houses the Larkin Gallery and Eckl's restaurant.

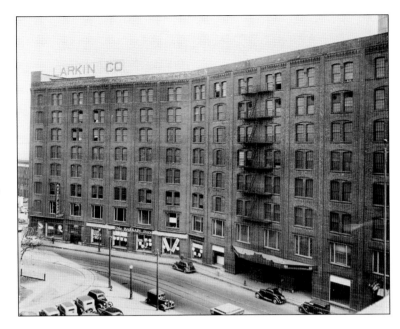

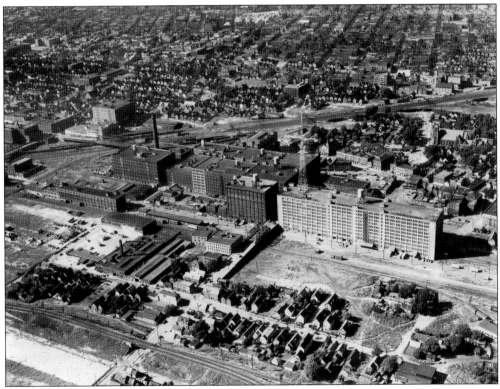

This aerial view of the Larkin factories from 1937 shows the elevated bridge of Van Rensselaer Street over Exchange Street. Also featured next to the Larkin Terminal Building is Building P. Many of the homes shown below the building have been demolished for a parking lot that is used today by the current employees and companies of Larkinville.

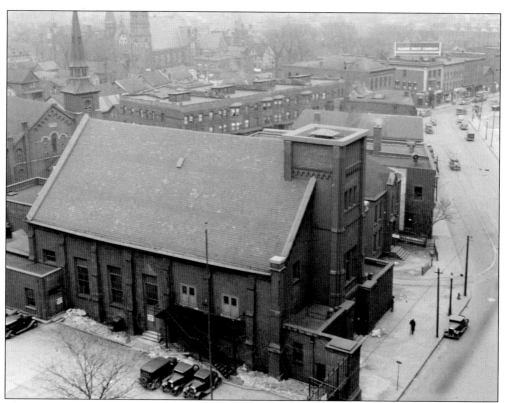

The Larkin Auditorium originally housed Sacred Heart Church, which established its congregation at this site in 1875. After the church constructed a new house of worship in 1913, the Larkin Company took it over and removed the large steeple (see page 16). Once the auditorium opened, it welcomed as many as 60,000 visitors by hosting moving picture shows and lectures. Since it was originally built as a church, the first floor had an open floor plan, allowing for seating of 500, plus 250 more in the balcony, to enjoy shows, conventions, and other events. Near the main entrance of the building was a luncheon area for guests and visitors, and at the back there was a Larkin showroom and kitchen, both completely furnished with Larkin products and premiums. In 1936, the building was beginning to be taken apart, as shown below.

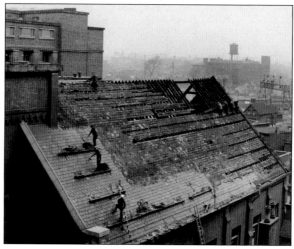

When the Larkin Auditorium was not being used for events or visitors, the space was set up with couches and reading chairs for employees. Here is the building with only the main entrance still standing. The sign reads, "Larger Parking Area Under Construction for Larkin Store Customers," representing the only way companies knew how to deal with the growth of the automobile—demolition of older buildings.

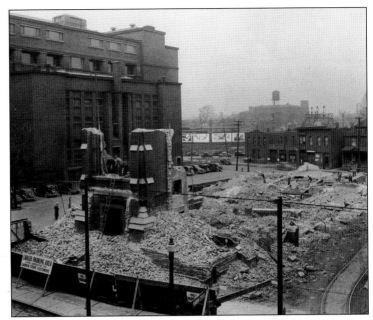

Another ancillary structure was the Service Building, located between the Larkin Administration Building and the Larkin Auditorium. In a construction plan from 1923, the Service Building housed the dental office and dispensary for the office workers employed in the Larkin Administration Building, and the school where employees could continue their education. For a time, it was also the headquarters of the Larkin YWCA.

The Men's Club building, still standing near the intersection of Seneca and Van Rensselaer Streets, housed the Larkin Men's Alliance, the first version of a men's club for Larkin employees. The goal was to allow for coworker companionship and engagement in intellectual and physical improvements. Most of the Larkin clubs for both men and women started to decline when the company did.

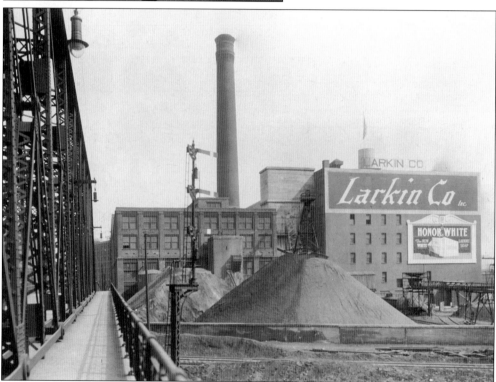

Constructed in 1902, the Larkin powerhouse was known throughout Buffalo for having the tallest structure in the city, its chimney, at 275 feet in height. The plant produced 10,000 horsepower and consumed 125 tons of coal every day. Three short railroad tracks, called spur lines, linked from the nearby New York Central Railroad, delivered the fuel. Pictured here are large piles of what could be lignite coal, based on the color.

Here is another image of the Larkin powerhouse from Seneca Street. The bins, chimney, and piles of coal are evident. At its greatest output, the powerhouse contained 10 generators—three 115 kilowatt hour, three 300 kilowatt hour, two 70 kilowatt hour, one 750 kilowatt hour, and one 110 kilowatt hour. These generators were located on the second floor of the structure, while the first floor contained the ash pits. Underground networks of piping led to each building of the complex.

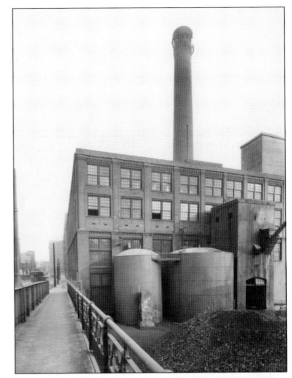

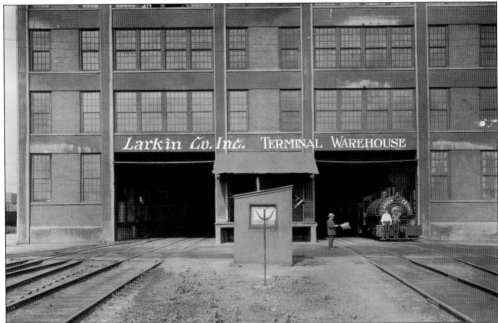

Here is the east end of the R, S, T Building, better known as the Larkin Terminal Building and now the Larkin Exchange Building. Constructed in 1912, the first floor was the main shipping and receiving arm of the Larkin Company. Pictured are four railroad tracks that traversed the building and entered Building P across Van Rensselaer Street. There were also 29 bays for trucks lining the north and south sides of the structure.

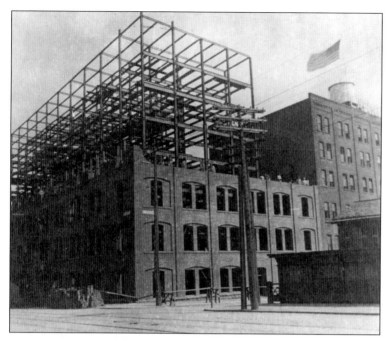

The construction of Building H is under way in 1900. This building supplanted the structures fronting Seneca Street (seen on page 31). By this time, Buildings C, D, E, F, and G had already been completed behind H. This was the time of great expansion for the Larkin Company. Once completed, H contained soap cutting and drying departments, the machine shop, and Boraxine soap production.

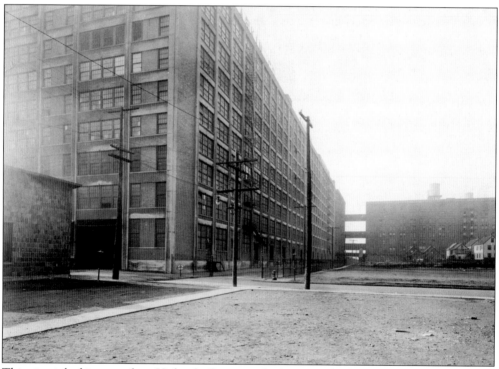

This view is looking west from Hydraulic Street, in the foreground. The Larkin Terminal Building is at left with its railway entrance, and in the distance, the three covered walkways connecting Building O to Building P are clearly evident in this 1923 image. Much of the open area is now taken up by the parking ramp for the employees of Larkinville. Also seen next to the Larkin Terminal Building is a stretch of Carroll Street that is now closed.

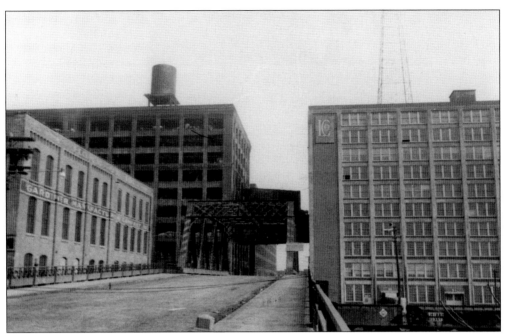

For anyone who works in Larkinville, the south side of the Larkin Terminal Building is recognizable, though Van Rensselaer Street may not be. During the time of railroads, this street was raised to accommodate the trains. At left is the Gardiner Manufacturing Company Inc., though it is believed that this building also housed the Anslem Hoefner Soap Company (shown on page 25).

In 1950, the Bison Waste & Wiper Company purchased Building P from Beals, McCarthy & Rogers Inc., which bought the building from Larkin at an earlier date. The company expected to use the first three floors and rent out the rest. In 1954, the building was engulfed in a terrible blaze, which called about 400 firefighters and 100 civil defense volunteers to the scene to contain it.

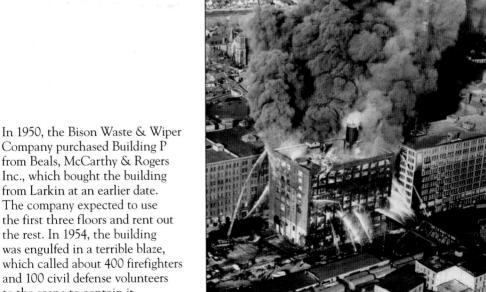

In 1900, a memo went out to the women of Larkin asking them to raise the hem on their work skirts to prevent the unnecessary spread of dust and other particles while they walked. These compliant women are shown outside the Larkin Administration Building in 1907. The building was unique in that it created a division of labor; office workers were removed from the sounds, sights, and smells across Seneca Street on the factory floors.

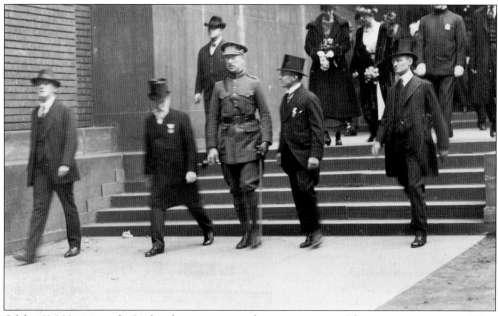

Of the 60,000 visitors the Larkin factories received every year, one of the most important was King Albert of Belgium. This photograph shows John D. Larkin, second from left, leaving the Larkin Administration Building with King Albert and his wife, Elisabeth, in the white dress behind them. After World War I, King Albert toured Buffalo, the Larkin factories, and other American cities to learn best manufactory practices to help rebuild Belgium.

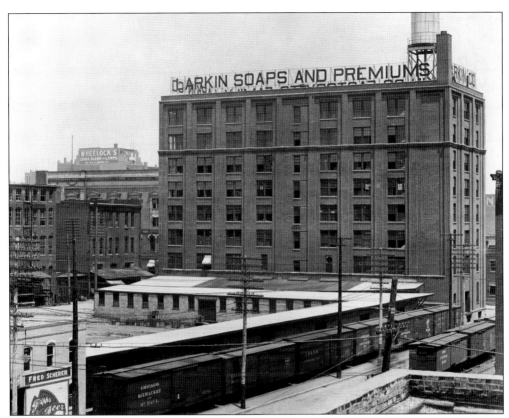

Established on April 1, 1902, the Peoria, Illinois, Western Branch House of the Larkin Company opened to serve Larkin customers west of the Mississippi River with quicker delivery, better correspondence, and lower freight charges. It opened as a storage, packing, and shipping warehouse but eventually became a showroom like those in New York City and Philadelphia. Pictured is the branch on Water Street.

The Philadelphia showroom and warehouse was established on March 1, 1902, and this temporary "Larkin Home" from 1913 showed many of the furnishings and premiums that the Larkin Company sold. Expansion was rapid during the first decade of 1900, and by 1905, the company had branches in Philadelphia, Boston, New York City, Pittsburgh, and Peoria, Illinois. Larkin employees included draymen who delivered goods directly to homes.

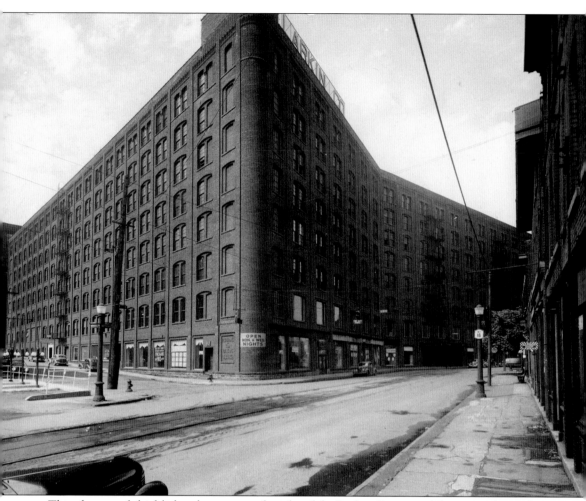

This photograph highlights the power and might of the Larkin Company. The image shows the corner of Seneca and Van Rensselaer Streets and its familiar facade to those who now work in Larkinville at the Larkin Center of Commerce. While the picture was taken at a time when the Larkin Company was leasing out space, one can imagine the 2,600 employees who once worked here. This is Building N, which once housed the department and employee store, the factory library, and the clothing and garment manufacturing and food and spice manufacturing departments. Engraved on the side of the building on Van Rensselaer Street is an advertisement for the restaurant and soda fountain on the main and second floors, but by this time, even though the photograph is undated, they had closed. As the company diminished, part was reorganized as a warehousing company, Larkin Warehouse Inc., with most of this building used as storage or factory space for other companies. Today, the 1.3-million-square-foot structure is home to almost 100 tenants and retail spaces and host to many yearly events.

Four

PURPOSE, EFFORT, ACHIEVEMENT

MANUFACTORY

With 10 years of experience behind him, John D. Larkin stuck with what he knew, and the first product was called Sweet Home Soap. This yellow cake, or bar, was designated for laundry use. Expanding out to Boraxine, a flaked laundry soap, the products and premiums grew quickly. In the 1897 Larkin product list, there are 16 products: 14 soaps for personal or laundry use, plus a cold cream and a tooth powder. By 1905, teas, soups, spices, and other foodstuffs entered the product list; by 1908, varnishes; by 1910, paints. In 1909, premiums were added to the product list mailer with full descriptions and sketches, and a traditional catalog took shape. By 1915, the expanded catalog was 176 pages, with 33 pages dedicated to over 700 products, 131 pages for Larkin premiums, and extra pages dedicated to teaching the Larkin Idea and the secretary-club model. This product and premium expansion created the need for building expansions. By 1912, the Larkin factory reached its greatest size with the construction of the R, S, T Building. Starting in 1896 with Building D, these 16 years of growth brought 21 new structures to the complex. All buildings constructed after 1896 followed the most up-to-date fireproof technology, while underground passages, connector bridges, elevators, and lifts were added to make the production and movement of Larkin products as easy as it could be given the company's complexity. Listed at over 60 acres of floor space and 2.1 million square feet, the factory was one of the largest in the country, though dwarfed by the Sears, Roebuck & Co. mail order complex in Chicago, at over three million square feet.

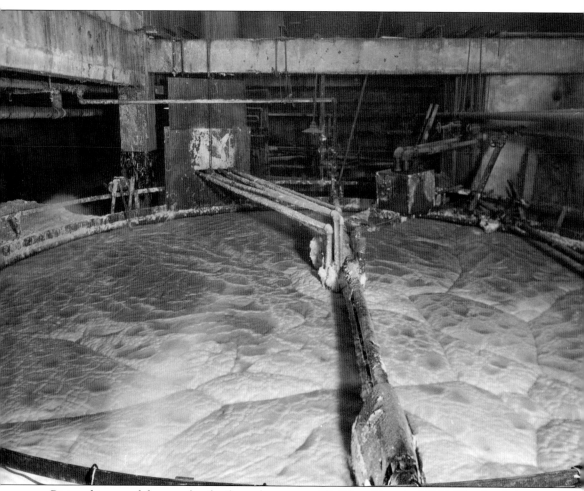

Pictured is one of the soap kettles from the annex of Building D around 1921. This kettle holds the third stage in the soap-making process. The tallow, or fat, and the lye, or caustic soda, have been purified separately and then combined in kettles such as these and boiled using hot steam pipes in the bottom of the kettle. Adding to its main product, Sweet Home Soap, the company introduced Boraxine in 1881. It was a flaked soap that came in a coarse powder. Both of these products were used for laundry. The company's first toilet, or bath soap, line was Pure White in 1883, and it quickly expanded to Mojestka Complexion Soap, Crème Oatmeal Soap, Sulphur Soap, Old English Castile Soap, Witch Hazel Shaving Soap, and Elite Glycerine Soap.

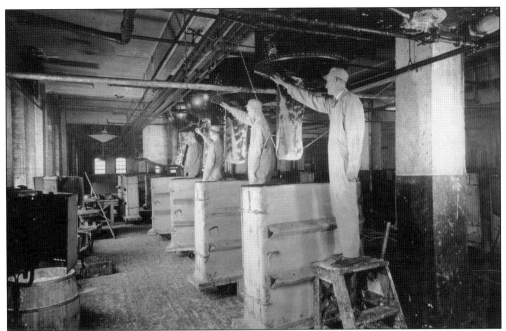

Here, workers man the levers of the "crutchers" to drain off the prepared soap from the kettles on the floor above. After reaching the right temperature and again drawing out impurities, the soap is drained from the bottom of the kettle into these crutchers, which spin the soap and add perfume or other ingredients. The product then gets extracted into the frames on the floor.

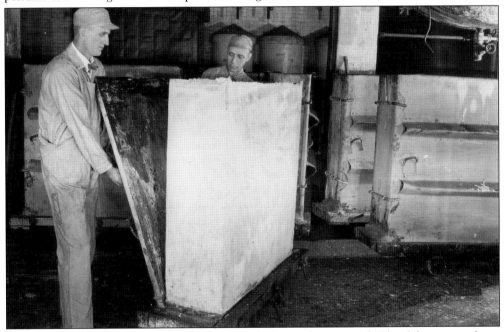

The product is allowed to cool in the frames, which are then opened. The slab is cut and run through a hot air kiln to facilitate drying. The cakes of soap are then wrapped in the proper packaging and sent to the warehouse for shipment. Here, two workers are opening a frame, exposing the 1,200-pound block of soap.

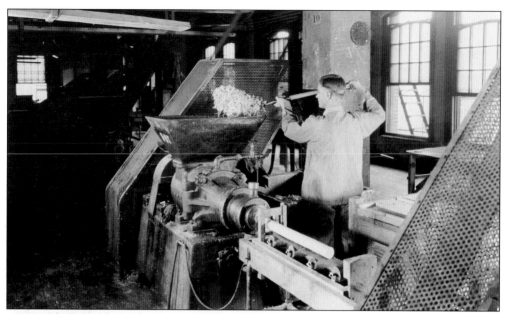

A worker is adding soap to a plodder machine. This machine took soap and pressed it into various shapes, while creating one final high-pressure environment to remove impurities. Not every soap product went through this machine, only products like Sandalwood Toilet Soap, which had a different shape than the traditional bar.

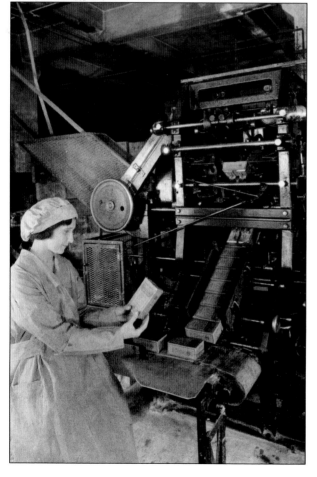

Boraxine was the second product made by the Larkin Company. It followed the process for soap making, but instead of being made into a bar, it was crushed and flaked into a coarse powder that could be added to tubs of water for soaking clothing or other textiles. Here, a worker is holding a finished box of Boraxine. It was also marketed as a general household cleaner to be used on home surfaces.

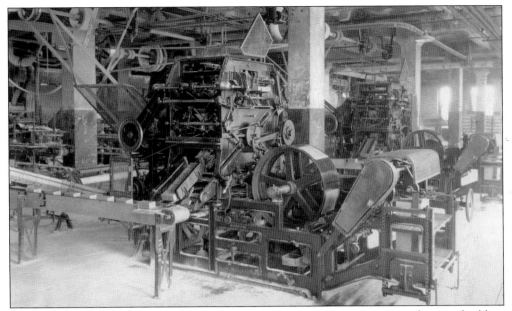

Here is an example of the machinery used in the packaging of Boraxine. According to a building index created in 1923, Boraxine products were created and packaged in Building H, the structure fronting Seneca and Larkin Streets, on floors seven and eight. In the 1923 catalog, Boraxine had a list price of one for 10¢ or a case of 50 for $4.50.

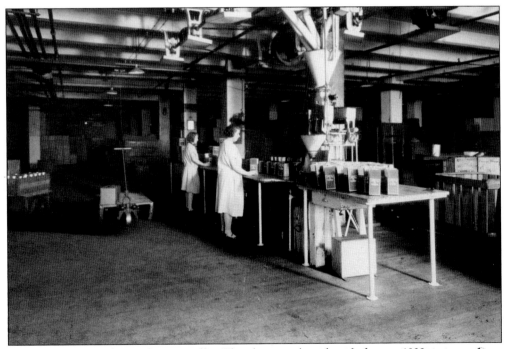

Pictured are two Larkinites boxing coffee. The photograph is identified as pre-1922, so it may have been taken as a "before" image, after more modern machinery was purchased. Coffee was prepped as ground or whole bean and came in one- or two-pound packages; it could also be purchased in bulk in a 30-pound case.

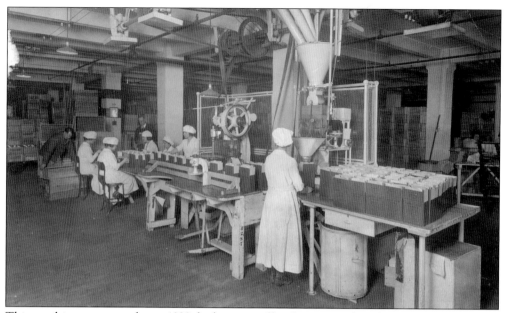

This machinery was used post-1922 for boxing coffee. It appears that the packaging has been streamlined slightly from the previous photograph, including more assembly line production and more workers. Larkin Club Coffee sold in a two-pound package for $1.40 and a case for $13.75. This image shows the sixth floor in Building K.

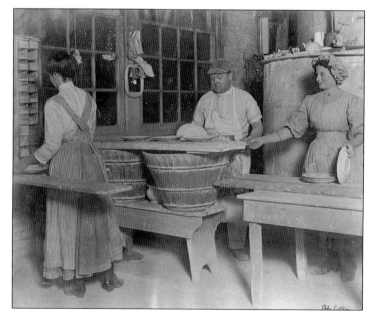

Buffalo Pottery was one of the best-known subsidiary companies of the Larkin Company. Three workers are shown in 1909. The company opened in 1901, bringing two executives in from the Trenton Potteries Company to manage the plant. Prior to its opening, the Trenton, New Jersey, plant produced china and kitchenware for Larkin. One of the company's most famous lines was Deldare, which featured painted scenes of English village life.

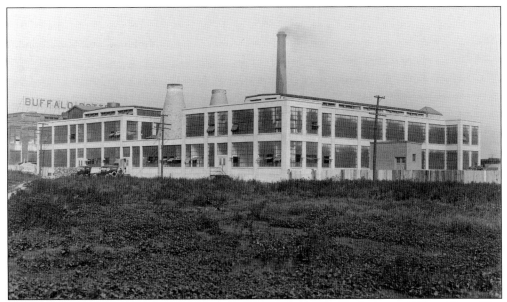

Here is the Buffalo Pottery plant in 1915, near the corner of Seneca Street and Hayes Place. The factory was in operation until 2013 under various names. Lewis H. Bown and William J. Rea came from the Trenton plant in 1901 to oversee the startup. About 350 people were employed with the company yearly, including molders, cutters, trimmers, painters, and designers.

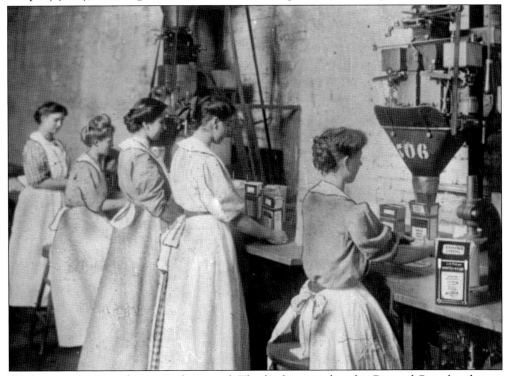

Workers are shown packaging Larkin cereal. The food was marketed as Roasted Cereal and was a "pleasing, healthful and economical substitute for coffee." It did not appear in the Larkin catalogs for long, as it was gone from the product list in 1921. It was sold in a one-pound box for 15¢.

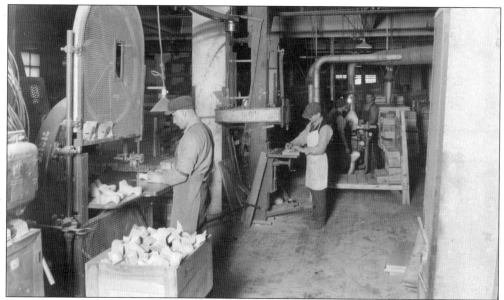

Workers from the chair department are pictured in 1920. At this time, the chair department consisted of four floors in Building P that were dedicated to making, spraying and dipping, and finishing and repairing. Pictured in the 1921 catalog, this image, taken that year, seems to capture the manufacturing of the Queen Anne wing chair, which was given away with the purchase of $122 worth of products.

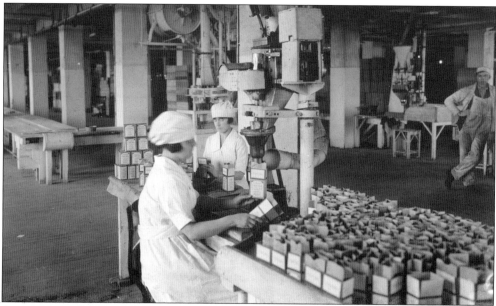

Cocoa was a popular Larkin product, and these workers are weighing and packaging it. This product was sold in half-pound packages for 25¢. It was marketed as "especially desirable for children on account of its nourishing qualities" and also an excellent product for making fudge, caramels, and icings. This image is from Building J, K, or N, as most of the general food items were prepared in those buildings.

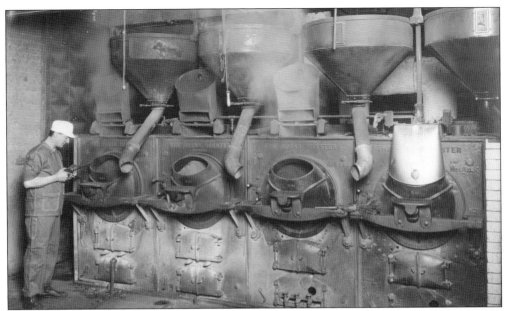

Pictured here are four coffee roasters and an employee testing and observing the coffee beans. The beans were spun and heated, which changes their chemical and physical formulation, making the roasted coffee bean more tasteful. The Larkin Company marketed this product as being "freshly roasted in our own factories," and this image backs up that claim.

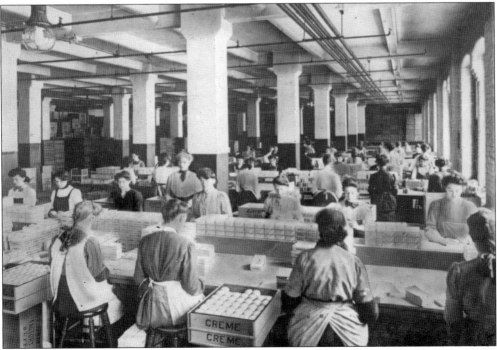

These Larkinites are packaging Crème Oatmeal Toilet Soap. This popular product was one of the first toilet soaps created by the Larkin Company. It sold in a box of three cakes for 25¢. The 1921 catalog states that it "contains the soothing properties of oatmeal, making it especially desirable for those with delicate skin." This image could be from Building K, fifth floor.

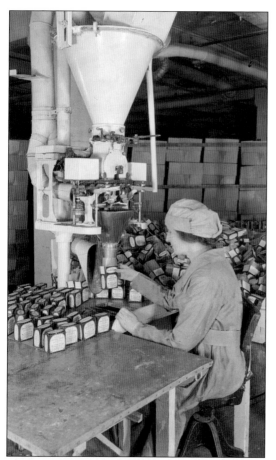

Food production took place in three different buildings: J, K, and N; this employee is in one of those buildings filling boxes of chocolate pudding. The pudding came in powder form. In 1921, at the time of this image, the company produced four different flavors: chocolate, vanilla, lemon, and orange. One package sold for 7¢.

A Larkin employee is mixing macaroni products. This 1922 photograph shows one of the three macaroni products produced by the company: short cut macaroni (similar to elbows), short cut spaghetti, and short cut noodles for soups and side dishes. The macaroni ingredients are being mixed together in bulk, and when processed into the products, they came in eight-ounce packaging.

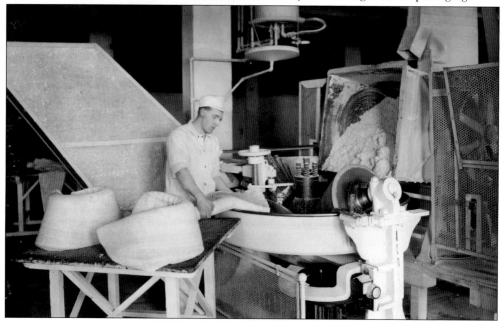

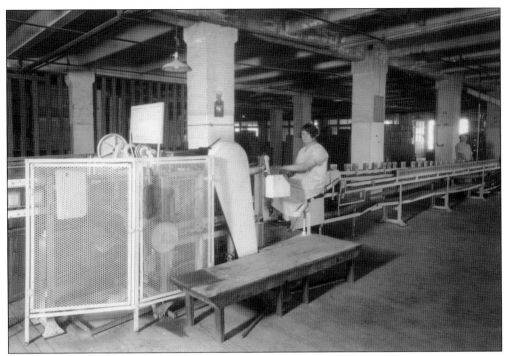

Two more workers in the macaroni department are shown here. This machine prepared the short cut macaroni packages. Here, the cartons were sealed on the bottom, then flipped upright and sent down the belt. The ready-to-use cartons were laid flat on the white shelf by the woman's left hand and were added manually to the sealer machine.

The Larkin executive group had put the safety of its employees at the top of any decision made. This company value stemmed from John D. Larkin witnessing the devastating fire in Chicago in 1871. This image shows machinery highlighted with safety screens. This photograph, taken in 1916, may have been used promotionally as there were many vocal labor and working-class organizations that targeted factory safety around the United States at that time.

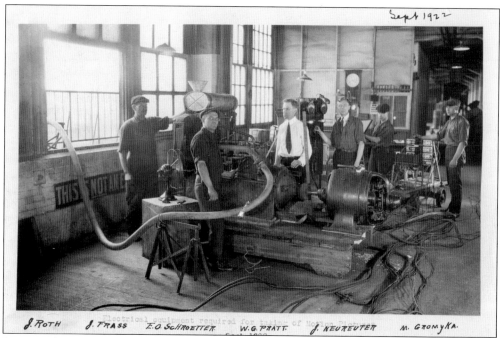

J. ROTH J. FRASS E.O. SCHROETTER W.G. PRATT J. NEUREUTER M. GROMYKA.

In 1922, the Larkin Company produced a series of films. *Getting Together*, a filmstrip about the Larkin clubs, is discussed on page 88. The film crew also recorded scenes around the Larkin factories, though it is not known what became of this film. Here is an image of the electrical equipment needed to support the filming along with the names of the employees.

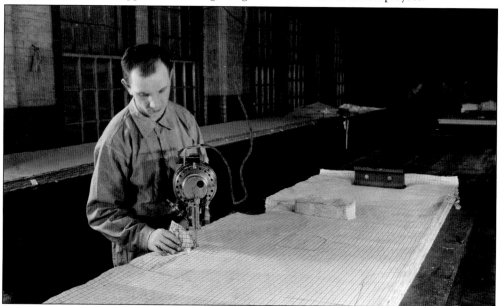

Muslin cotton has been used in cloth making for centuries. The Larkin Company made a wide variety of nightgowns, boy's and girl's underwear, and men's union suits. This particular pattern was not in the 1922 catalog, when this picture was taken, but the image shows an employee cutting pieces to be stitched together at another workstation. Garment manufacturing took place in Buildings K and N on the fourth floor.

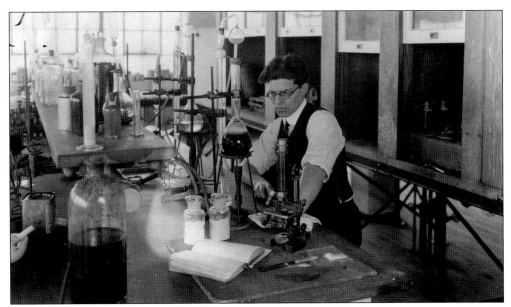

Pictured here is a Mr. Hoyt in a research lab in 1924. In the 1924 city directory was a Lester F. Hoyt, who was a department manager with the Larkin Company and resided in East Aurora. There were research labs throughout the Larkin Company, especially in the food, perfume, and soap departments, but it is not known exactly where this photograph was taken. In 1912, the general research lab was located in Building H.

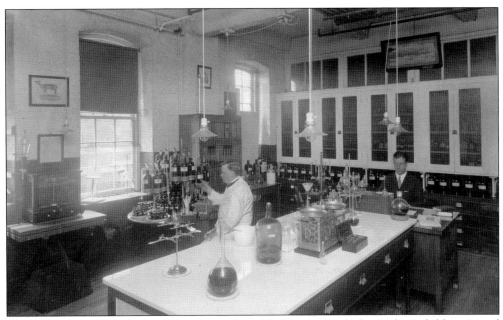

Pictured is Harry H. Larkin, right, in the perfume lab. Harry, one of John Larkin's children, joined the company in 1909, eventually steering it through its liquidation after becoming president in 1936. Coinciding with his management duties, Harry was also the director of the perfume and pharmaceutical department. The other employee is C.F. Booth.

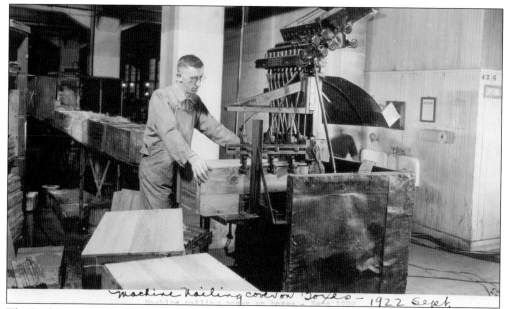

machine nailing cover on boxes – 1922 Sept.

The Larkin product boxes became collectable after the company closed. The Larkin Company always looked to recycle and save money where it could. To that end, the company created a send back program. If customers returned 12 boxes in good working condition, they were given a free premium. Here, a worker is using a cover-nailing machine to secure products in boxes.

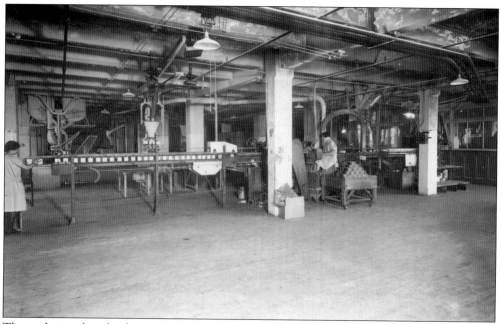

The packaging line for the cocoa product can be seen here. Expansion of machinery allowed for assembly line production of boxes. Similar to the machine shown on page 71, this line took flat boxes, opened them, and sealed the bottom and turned them upright to be filled with cocoa. The pyramid on the table next to the worker at right consists of flat cartons before being placed in the machine.

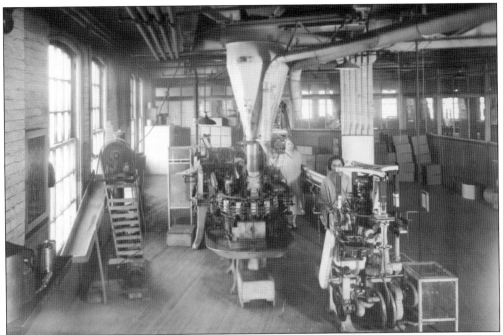

Here is another view of a packaging machine for an unidentified product. As in many of these images, women are working the machines. John Larkin believed in hiring women for the workplace, and roughly 60 percent of the workforce in any given year was female. In the right foreground are the four machine spindles that opened the flattened boxes, sealed the bottom, and brought them back to the worker for placement on the line.

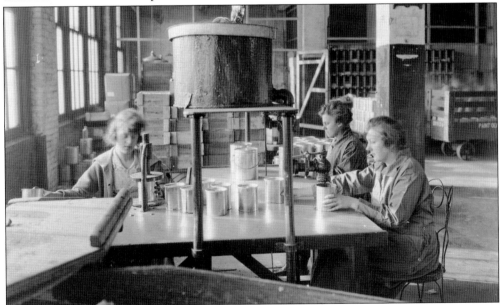

The Larkin Company began selling house paint in 1910. It had previously sold varnishes beginning in 1908. These were Larkin "products," a growing list of items separate from the premiums. Pictured are three female employees working in the paint department. The two women at right are filling the paint, and the woman at left is sealing the filled cans. A vat of paint sits above them.

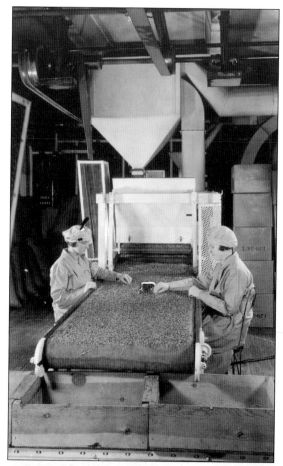

Here, two employees sort and inspect peanuts. The peanuts have gone through the hopper and chute and are on the conveyor belt, which empties them into the boxes in the foreground. The Larkin Company produced its own peanut butter, which was sold in eight-ounce jars. Each sold for 35¢ and was made from the "finest grade of specially selected peanuts, roasted and ground in our clean, light, sanitary factory." While the women in the image at left must be "specially selecting" those peanuts, the woman below is filling the peanut butter into the eight-ounce jars. In the Larkin catalog, the peanut butter jar is glass, and this image confirms that. The label was placed on the lid, so the peanut butter could be seen from all angles in the jar.

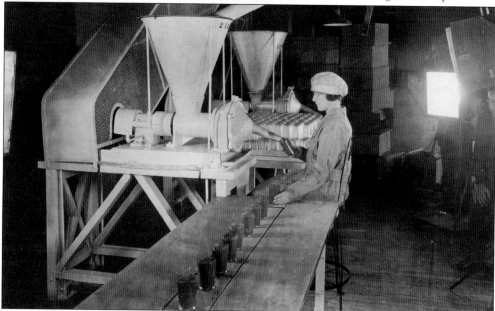

Here, a Larkinite shows off the purity of Larkin's Vanilla Flavoring Extract. This product was made and preserved in alcohol or glycerin and sold for 40¢ a bottle. Also pictured are the vanilla beans used to make the extract. Other extract flavors included onion, almond, lemon, maple, orange, ginger, peppermint, and wintergreen. As a responsible company, it was explicitly stated that "no more than five bottles of any one flavor of alcoholic extracts will be shipped with one order."

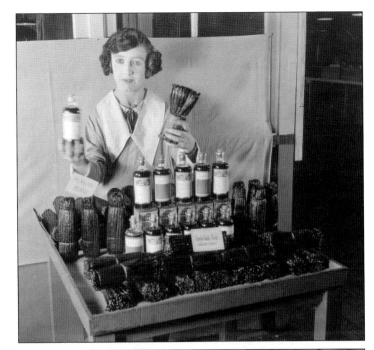

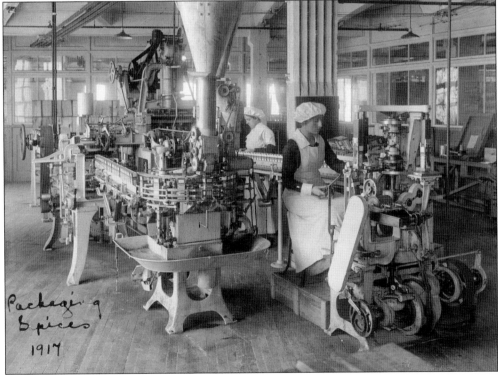

Along with the extracts listed above, by 1905, new products included in the product and premium catalog were spices. Here is a 1917 image of Larkinites preparing the packaging for cloves, which sold for 15¢ in quarter-pound boxes. Shown is the machine and the line that prepares the flat boxes to be filled with product by opening and sealing the bottom.

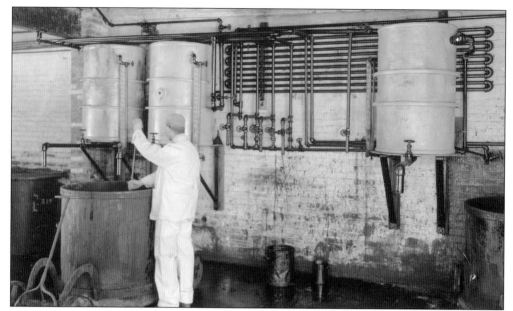

Pictured are the mixers for large production of paint. Beginning in 1909–1910, the house and floor paint line included colors such as drab, light blue, buff, chocolate brown, pearl gray, fern green, yellow, and orange-yellow, among others. The customer could also request samples of the paint before purchase, as the Larkin catalogs during that time were not colorized. This production took place in the collection of small buildings labeled Q.

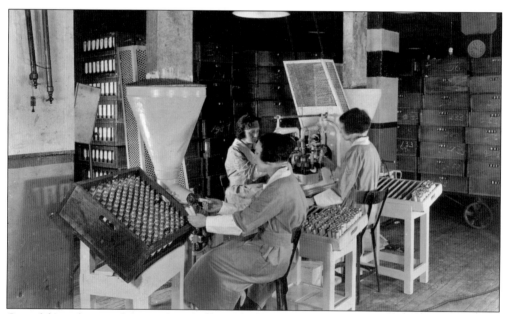

One of the earliest products marketed after laundry and toilet soap was the Mojeska Tooth Powder. In 1904, the company added other tooth products to its growing list of goods. The first, called Larkin Liquid Dentifrice, was in liquid form and came in two-ounce bottles for 25¢. Seen here in 1922, employees are filling tubes of toothpaste that were marketed as producing less lather than other dental products.

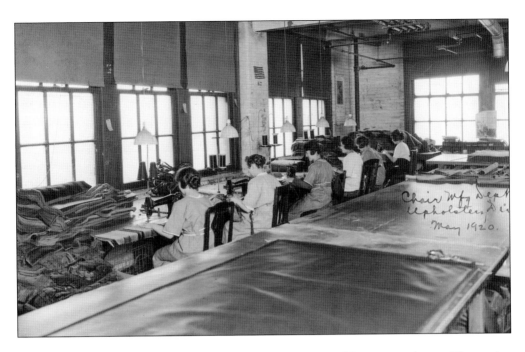

Above, the upholstery department for the Queen Anne line of furniture is shown. The catalog spoke of this product as "combining the grace and dignity of the Queen Anne Period with the comfort and serviceability of modern furniture," and this upholstery came in various patterns and colors of velour. Under the Queen Anne line there were the Fireside Suite and Parlor Suite furniture sets. The image below shows an employee adding the "tow" and a heavy layer of cotton to what appears to be the company's English rocker, sold in the 1922 catalog. Tow is a coarse, fibrous material that in some products was added alone, or mixed with goat hair.

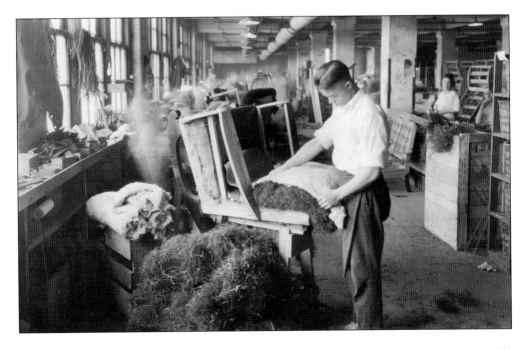

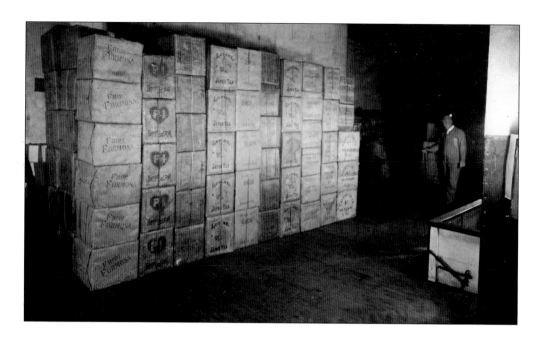

The image above shows tea leaves being stored for pre-production. Tea products were packaged on the sixth floor of Building K, so this image may have been captured somewhere in that structure. Many Larkin food products were first developed and manufactured for the 1905 catalog, and teas were included. The first teas came in one-pound cans titled Ceylon, English Breakfast, Formosa Oolong, Japan, and Mixed and cost 65¢. By the 1910s, teas also came in half-pound packages and were sold for 35¢. The image below shows Larkin employee P.G. Harlow taste testing a variety of teas for smell, color, and taste. The tea was also packaged as loose leaves that had to be infused and strained by the customer.

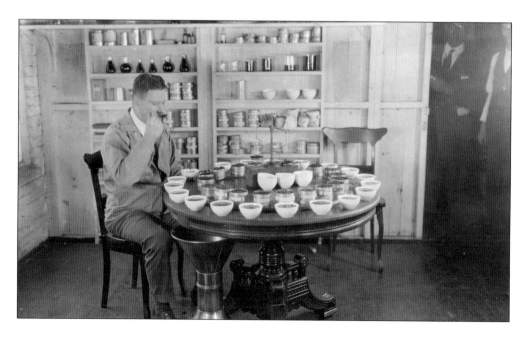

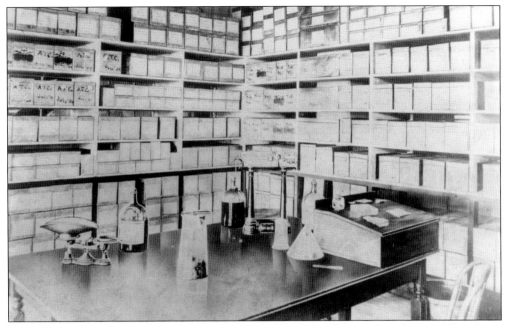

Here in Building F on the fifth floor was the vanilla vault. This image, taken in 1934, shows extracts being quality tested for purity and content. It is presumed that all extract products made by the Larkin Company were treated in this room for quality testing. As previously mentioned, extracts were alcohol or glycerin based, and there were rigorous standards to follow after the Food and Drug Act of 1906 became law.

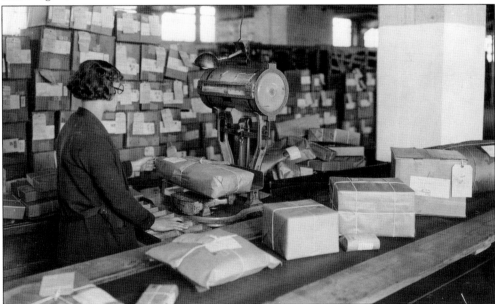

The R, S, T Building became known as the Larkin Terminal Building. Here, in 1924, a Larkinite is weighing packages to be loaded onto one of the trucks stationed at one of the 29 bays or one of the four rail lines on the first floor. In the background, some of the other shipments are waiting to be loaded. On the boxes are the cargo manifests from the transporting company, whether that was a Great Lakes freighter, a train, or an automobile.

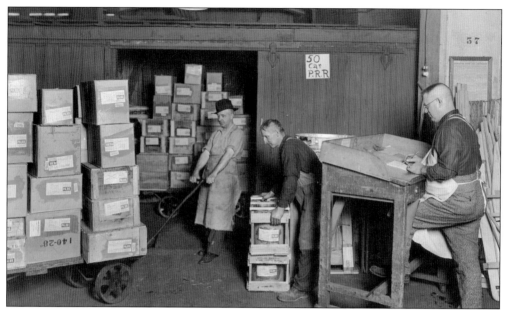

The R, S, T Building was constructed in 1912 and had four rail lines laid into the ground floor. As shown on page 55, the track was on the ground and underneath the first floor of the renovated building today. Here, product is being loaded for shipment on the Pennsylvania Railroad, originally known as the Buffalo, New York & Pennsylvania Railroad before merging and changing its name in 1900.

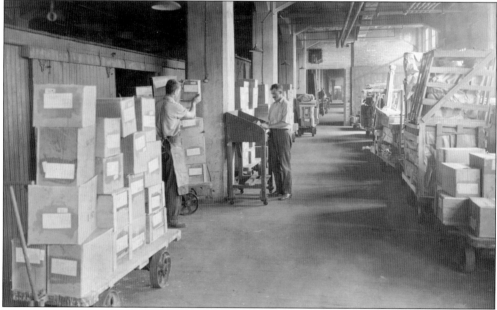

Here is another image of the R, S, T Building in 1921. The Larkin Company was receiving thousands of letters, orders, and correspondences a day. With rail lines on three sides of the Larkin complex and its own "Larkin the First" locomotive and spur line, the company's need to have an organized plan for moving freight was imperative. Here, freight is being loaded onto cars of the Erie Railroad.

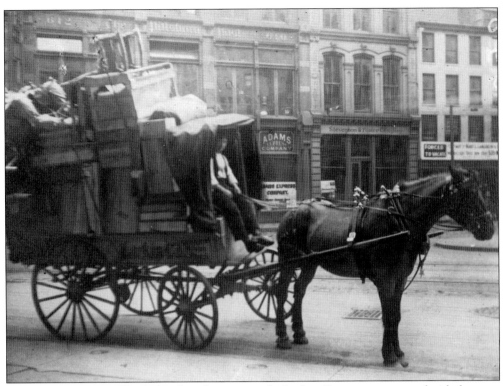

Once packages were offloaded at their destination, the Larkin Company contracted with draymen who would deliver the goods to each household. These could be enterprising individuals or larger companies. Drayman turnover was quite high, though no explanation is given in the records. Here are two images of draymen at work. The image above is from Pittsburgh in 1910 in front of the *Pittsburgh Post* newspaper office at the corner of Wood Street and Liberty Avenue. The image below comes from New Haven, Connecticut. The Larkin Company contracted with the Peck & Bishop Company, a forwarding and shipping company. The Larkin Company had a dray department that corresponded with its forwarders in each of its regions.

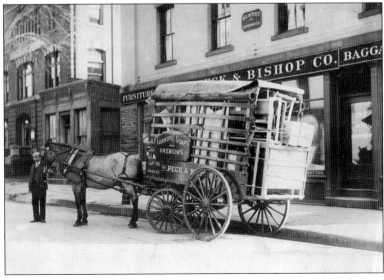

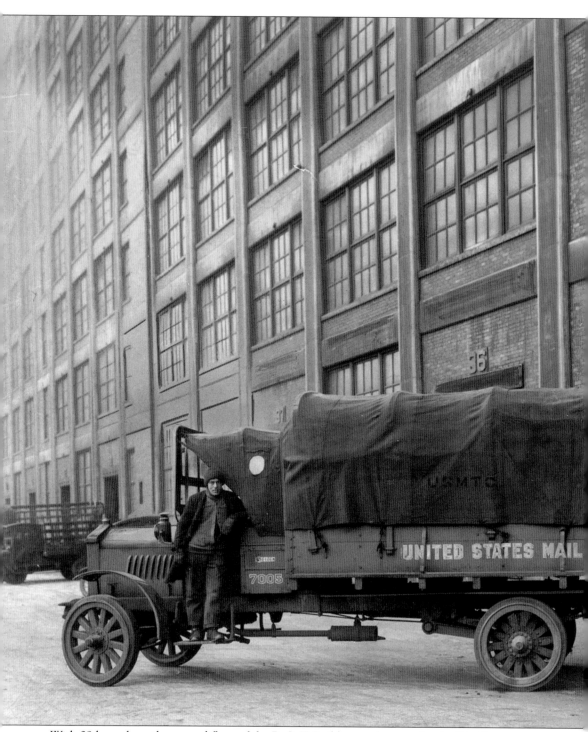

With 29 bays along the ground floor of the R, S, T Building and a capacity for 40 railcars at any given time, this structure, also known as the Larkin Terminal Building, was ideal for shipping and receiving goods. It has a storage area of 600,000 square feet spread across 10 floors. Pictured is a truck from the US Postal Service picking up Larkin premiums and products at bay 35 for delivery

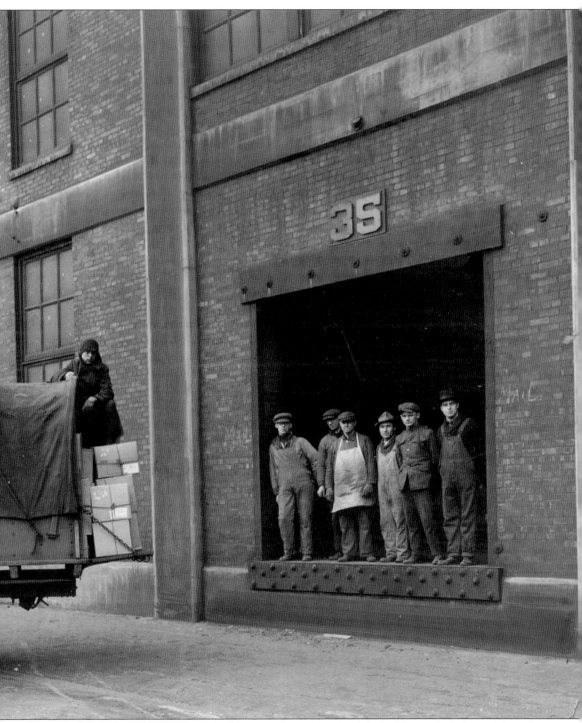

across the eastern United States. Bay 35 was on the north side of the building, which fronted Carroll Street, this portion of which is now a walkway with greenery and a playground. The building, constructed by the Aberthaw Construction Company of Boston, was made of brick, steel, and reinforced concrete. It was outfitted with sprinklers and was divided by firewalls and doors.

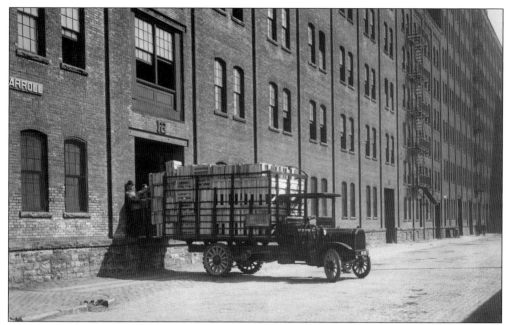

Three railroads dominated the western side of the Larkin factories. The Pennsylvania Railroad, the Lake Shore & Michigan Southern Railroad, and New York Central & Hudson River Railroad gave the Larkin Company easy access to the eastern seaboard and points west of Cleveland. Trucks, like the one above, also delivered goods to Buffalo Harbor to be loaded onto lake freighters. The image below, from 1911, shows a Larkin truck loading onto a New York Central & Hudson River Railroad train. Larkin factories had staging areas called carlot packaging departments—floors that would be dedicated to staging freight to match the square footage of railcars. Once the square footage of these staging areas was met, the products were sent to the shipping department for actual shipment, knowing that all of the products could be accommodated in a car.

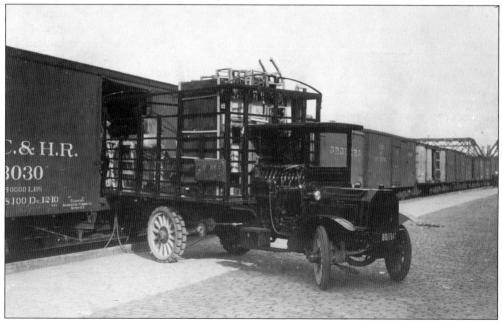

One

INTEGRITY, LOYALTY, FIDELITY

EXPANSION

With the product and premium list expansion, Larkin began expanding its branches and factories around the country. Energized and buoyed by the Larkin exhibit at Buffalo's Pan American Exposition in 1901, the company constructed a Philadelphia showroom and warehouse in March 1902 and one month later opened a Western Branch House in Peoria. Internally, a correspondence department was created to manage the growing interoffice communications. By 1904, branches and warehouses were constructed in Boston, New York City, and Pittsburgh, with one in Cleveland opening in 1905. The company began attending various state fairs around the country to continue getting its products and premiums into potential customers' hands and also created the Larkin Church Aid Plan to assist churches with raising money. In 1908, the Buffalo showroom for visitors and employees opened on the first floor of Building N. Having branches situated in large cities helped the company with transportation and social issues of the day. During winter months, most rail lines gave first rights to coal companies, as it was the primary heating system for businesses and homes. This affected Larkin deliveries, especially around Christmastime. To move products shorter distances, the branches were an ideal solution. The branches sold products to shoppers directly, but those "beyond wagon limits of local branches" were recommended to still use the Buffalo headquarters or the Peoria Western Branch House. The branches also addressed "Peddler's Bills," legislative bills introduced in states around the country to require peddlers to be certified, which the company believed would hurt its marketing. Having branches would curtail that loss of marketing. The company's expansion, which began in earnest in 1901, was fully realized throughout the first two decades of the 1900s to great success.

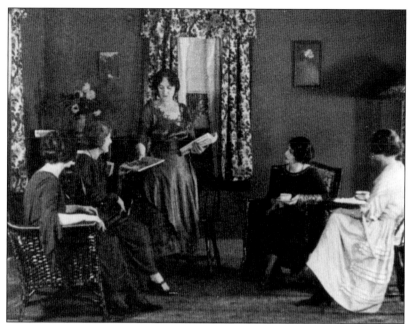

Here are two still images from the filmstrip *Getting Together*, produced by the Larkin Company in 1922. This filmstrip may have been in response to the loss of Larkin Secretaries beginning in 1920. Here is a Larkin Secretary and her club members in the home. The image above shows the secretary passing out the Larkin Catalog to the members, while the one below shows the members admiring silver-plated tableware. This item, listed in the 1922–1923 Larkin Catalog and produced by the Oneida Community, came in sets of six for $9. They were guaranteed to give "20 years of satisfactory service" to the purchaser. The company that produced these products grew out of the town of Oneida, New York, established as a religious communal society. Oneida Community Ltd. started producing kitchenware in 1899 and is still in existence today.

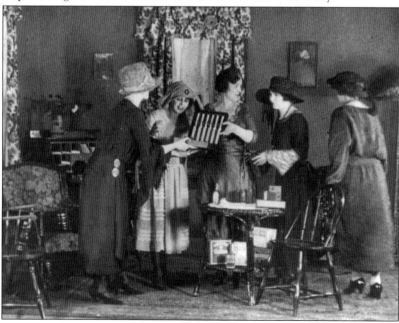

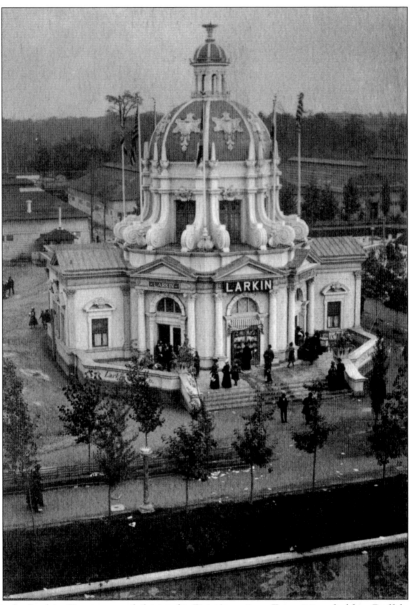

Shown is the Larkin Company exhibit at the Pan American Exposition, held in Buffalo in 1901. Larkin was the only company to be highlighted with a standalone exhibit, though there were other products and companies featured throughout the exhibition. The Larkin Company stated that over 810,000 exposition visitors came through this building after a turnstile was installed on June 10, 1901. The exhibit was set up with adjoining rooms off a main circular space. This central space highlighted the last stages of soap production, with a freshly wrapped bar of soap given to each visitor. The adjoining rooms included a reception room, dining room, library, music room, and bedroom that were furnished exclusively with Larkin products. *The Larkin Idea*, the monthly magazine sent to Larkin Secretaries, was established in advance of the Pan American Exposition. This first volume contained information on the soap- and perfume-making process, the step-by-step process of how the Larkin Company filled mail orders, information on the Larkin powerhouse, and other articles. (Courtesy of the Buffalo and Erie County Public Library.)

The Cleveland branch of the Larkin Company was established in 1905, a few years after the branches in Boston, New York City, Philadelphia, and Peoria. These branches served as showrooms and warehouses for a big city presence while being able to deliver goods in a timely manner. The image above, from 1923, shows participants in a Larkin fashion show attended by 760 women. Presumably, the children and women standing were some of the models. The image below shows a demonstration being conducted in the Cleveland branch in 1908. Some products are visible, such as the Oriental rugs hanging from the back wall and furniture pieces at lower right.

A Chicago branch opened in 1912 and was the headquarters for 11 states plus half of Illinois, as that state was broken up between both the Chicago branch and the earlier established Peoria branch. Orders from Arizona, Montana, and Oregon came to this branch. Here are Larkin employees on the roof in honor of Flag Day in 1917.

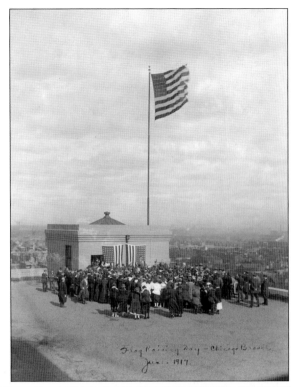

The Larkin Company expansion included attending many state fairs throughout the country. The prosperity that arose starting around 1900 was continued through these direct connections with consumers. Shown is the Larkin booth from the Iowa State Fair in 1913. Various toiletry products are on display in the cases, along with furniture and information on the Larkin clubs.

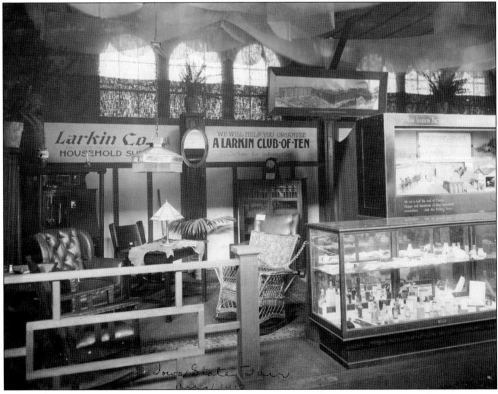

In celebration of the 300th anniversary of the founding of Jamestown, Virginia, that community held a celebratory exhibition from May through November 1907. The Larkin Company participated with its building designed by Frank Lloyd Wright, shown here. This exhibit hosted a daily talk on Buffalo, Niagara Falls, and the Larkin Company and displayed various premiums and products in over 1,500 square feet of space. Larkin also won gold medals from the exposition for the building design and its products.

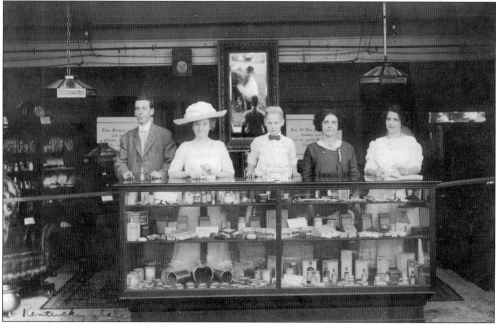

The display at the Kentucky State Fair is pictured here in 1912. Again, Larkin products such as laundry and toilet soaps, perfumes, toilet waters, and food specialties are shown in the display cases, while furniture, kitchenware, and other premiums are pictured at left. The photographer's reflection can be seen in the mirror behind the display case.

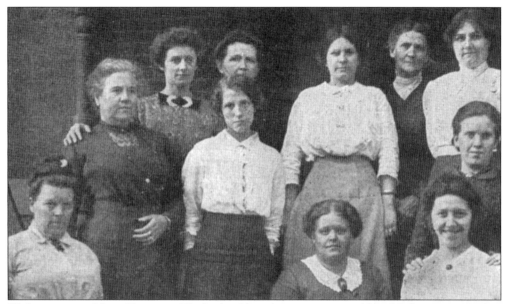

Within its monthly publication, *The Larkin Idea*, the company would highlight various Larkin clubs around the country. Here is an image of Mrs. John Coleman's Club of Ten from Kansas City, Missouri, in 1913. Also included in this November 1913 edition is an article introducing the Larkin Secretaries to the Club of Sixteen. Instead of a $10 monthly order with one premium given, a Club of Sixteen would send in a $20 monthly order with two premiums given per month.

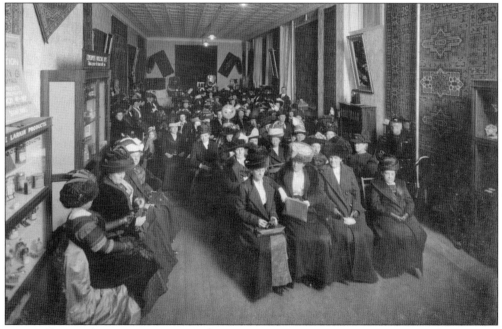

Pictured here is the Conference of Secretaries from Worcester, Massachusetts, in 1912. While the actual place of the conference is not known, the walls and display cases highlight Larkin products, which could place it in a showroom in the Boston branch or a Larkin traveling showroom. This image is from March 5, 1912, and is a great example of the bond between the Larkin Company and its customers.

In 1923, the Larkin Company created a new district sales plan with the development of the "Major Secretary." Unveiled in Erie, Pennsylvania, major secretaries were experienced secretaries promoted to "teach and aid other Larkin Secretaries to accomplish greater Larkin achievements." With the loss of profits beginning in 1920, the Larkin Company decided to develop unique ways of keeping secretaries. Pictured here is John D. Larkin with some Major Secretaries from around the country in 1924.

Promotions such as the 1924 "Let's Go to Buffalo" kept Larkin Secretaries and customers engaged with the company. Here is John D. Larkin and his son John D. Larkin Jr. with contest winners in that promotion. In *The Larkin Idea*, the months of April (Maid O' the Myst), May (chocolate pudding), and June (Witch Hazel Shaving Cream) highlighted those products. Those who sold the most of that particular product in a prescribed week would be entered to win the contest.

The Larkin Church Aid Plan was established in 1905 to address a question: Could Larkin products be donated for church fairs or bazaars? With the creation of the booth, the church was able to make money on Larkin products with little cost to the organization. With a $10 order and a request, the materials shown in this image, from 1924, were included, with all proceeds going directly to the church itself.

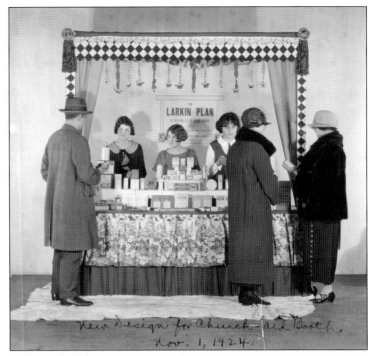

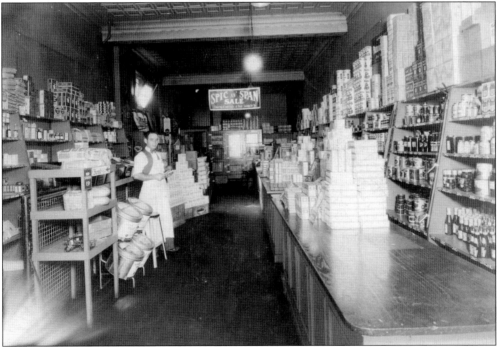

A Larkin Economy Store at 1127 Broadway in Buffalo is shown here. Beginning in 1918, Larkin opened economy stores selling food products. Food production in the Larkin factories was so high that the mail order and Larkin Secretary model was not able to handle all of the orders, creating a need to move product by other means. Economy stores were based on a cash and carry model and were "trimmed down" food stores, having minimal diversity of products.

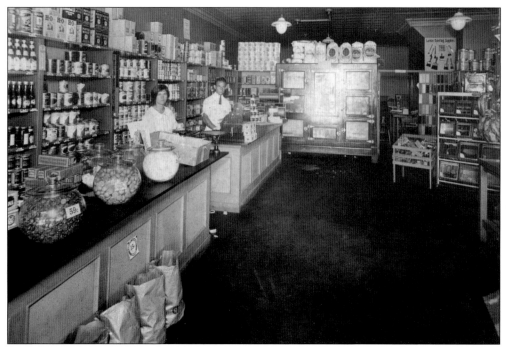

Walter and Annette Horst ran Larkin Economy Store No. 8 on Hertel Avenue. During its prime in 1922, there were 103 Larkin Economy Stores in Buffalo and western New York, but most were sold to Danahy-Faxon in 1937, while the stores in and around Peoria were sold to the Kroger Company. These sales coincided with the growth and saturation of national chains and new "supermarkets" into the Buffalo area.

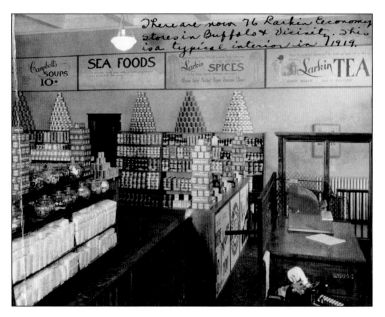

The Larkin Company had also expanded into more "regular" retail stores beyond the economy store. The company was slow to adapt to selling nationally branded products but was on board by 1923. This image shows products like Campbell's and Nabisco next to Larkin-made products. Profits from these retail outlets were mixed, with most stores in the red for multiple years.

Here is the Buffalo showroom from 1916 in Building N, on the corner of Seneca and Van Rensselaer Streets. This was the City Sales and Employee Store, opened in 1908 to cater to Buffalo residents, employees of the Larkin Company, and visitors. Here, the company promoted its products and premiums, which had expanded to 1,200.

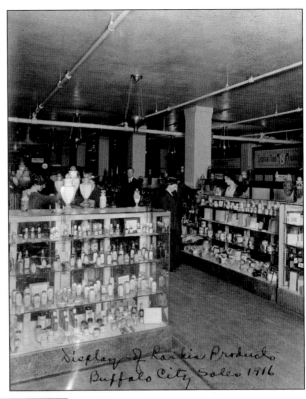

Display of Larkin Products Buffalo City Sales 1916

Marion Harland, well-known author of the 1872 book *Common Sense in the Household*, toured the Larkin factories in 1912. The Larkin Company published her work *My Trip through the Larkin Factories* in 1913. Over 94 pages, Harland gave an extremely detailed description of the factory, floors, production, and buildings. The Index of Buildings and Floors in the back of this book is based in part on that work. Harland is pictured here around the time of her visit.

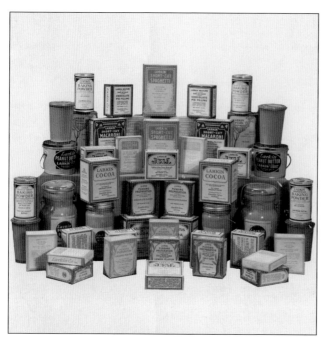

Here is a food advertisement from the 1920s. Following the model laid out when the Factory to Family/Larkin Idea was developed, the Larkin Company relied on its catalogs, newsletters, and word of mouth to market its products. Ancillary marketing took place in farming and church newsletters. With a shrinking Larkin Secretary base in the early 1920s, the company moved on to more traditional marketing techniques. The diversity of Larkin food products is evident.

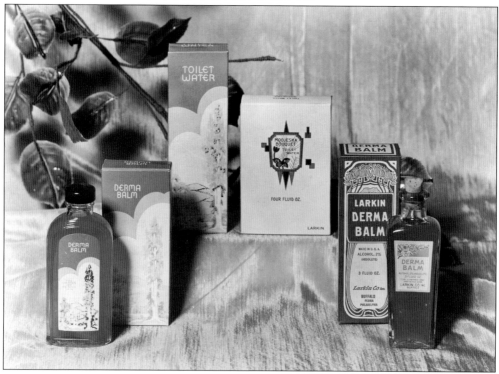

Another marketing image from 1934 shows some Larkin lotions and toilet water. By the time the Combination Box plan was developed in 1886, some lotions were already in production. The 1897 premium catalog lists Modjeska Bouquet (perfume) and Modjeska Cold Cream. By 1905, the company had expanded this line of products to include 12 different lotions, toilet waters, and toilet powders.

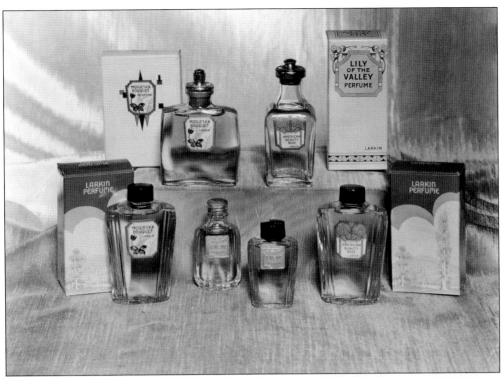

Selections of Larkin perfumes are shown in this marketing image from 1934. The Modjeska Bouquet, the company's first perfume, was named after Helena Modrzejewska, a renowned theater actress from Poland who immigrated to the United States in the 1870s. Harry H. Larkin supervised the Larkin perfumery department when he entered the business in 1909. Most of the production and packaging for these products took place in Buildings E and F.

The Larkin Company entered the varnish business in 1908, and paint production and supplies in 1910. Here is a paint exhibit from 1924, and a sample display with painted clapboard to show the colors. Most of the paint and varnish production and storage took place in the collection of eight Q buildings.

OUTPUT IN POUNDS FOR PAST SEVEN YEARS.

	1900	1901	1902	1903	1904	1905	1906
Home	23412225	26654475	35309624	39703500	46477821	52449056	53184931
Bxne	5958619	7349010	10352067	14041635	15626918	17322278	17386030
Mist	1575	997587	2889250	4141890	4126162	4538950	5028608
W. Woolen	1456409	1631565	1972674	2892209	2898375	2868667	2738899
Honor Bright	1093788	1112104	1552299	2097594	1996842	2016440	2042311
Harness	55804	62831	72372	70771	54448	45677	48884
Good Health		56700	63720	20090	71120	48363	67392
World's Work				850778	895833	921557	930515
E.Z. Scouring				18750	26250	29700	2812
E.Z. Hand						302	1800
Tobacco							
Toilet Soap Ala				32358	39252	33789	30376
							7630
Elite	1000353	1008392	1218897	1261504	1318907	1219284	1289019
Tar	759237	846911	1090288	1089484	740008	600416	710414
Creme	545898	549103	636121	690742	678015	740723	752539
Castile	417703	426018	542137	622624	588551	594637	597378
Sulphur	118895	125028	243892	229666	245317	194285	205264
Safeguard			32261	374429	439783	407056	401507
Mod. 4oz	119302	116087	186814	191818	192780	151956	153849
" 1/4oz	12048	12230	7130	1064	4280	13672	64848
Shave Stix	100041	98962	128624	130102	84322	86693	84365
" Tabs	22090	43625	71969	76465	75602	95911	110684
Golden Glow	97851	316376	342429	315677	338500	304790	311589
Tartan					401690	850244	965070
Clover							45064
Clover Sml							538
Sandalwood							20350
	35170838	41407004	56711568	68353150	77220776	85534446	86882668
		17 3/10% over 1900	37% over 1901	20 1/4% over 1902	13 1/2% over 1903	10% over 1904	1 1/2% over 1905

Here is a memo titled "Output in Pounds For the Past Seven Years," one highlighted in the introduction to this book. On the left side of the ledger are the product names; soaps and cleaning products are contained in the upper cluster while creams, lotions, and toilet waters are in the lower cluster. The columns show how much product, in pounds, was manufactured in the years 1900 to 1906. Twenty-three million pounds of Sweet Home Soap, Larkin's first product and listed at the top of the ledger, were produced in 1900. By 1906, that more than doubled to 53 million pounds, showing that production needs increased to meet high demand. Jet Neatsfoot Harness Soap (listed as Harness) saw production fall from 55,000 pounds in 1900 to 48,000 pounds in 1906. This ledger also shows the growth of the Larkin product line, not to be confused with its premiums. Products such as World's Work Toilet Soap and Tartan Tar Soap began production in 1903 and 1904, respectively.

Six

LIBERTY, EQUALITY, FRATERNITY

SOCIAL WELFARE

The explosive expansion beginning in 1900 did not exclude the growth in number of Larkin employees. In 1900, there were about 1,000 Larkinites; by 1907, that number had grown to 2,250 in Buffalo and 300 in the various branches. In the spirit of cooperation and service to fellow man, the company created a savings department for its employees in 1899, reduced the number of working hours in a day and added a coffee break in 1900, and instituted vacations for employees in 1901. Newer employees could take one week off without pay, while others were entitled to a one-week vacation with pay. For long-serving employees, employees who were never tardy for work, or those who were not absent for one whole year, the company included a second week with pay. The company began holding Christmas parties in 1904, and in 1906, the Larkin Benefits Association was developed to help employees in times of sickness or death. The biweekly employee publication *Ourselves* began listing those employees (or their families) who had been helped by the Larkin Benefits Association. In addition to these benefits, an education department was set up in 1907 to assist with those going to school in Buffalo or on the factory and office grounds. Citizenship, home economics, and English classes were established to help employees, especially those new to the United States, adapt. In 1905, a Larkin YWCA was established to run recreational and other educational programs. Also listed throughout *Ourselves* were programs, excursions, athletics, departments, marriages, deaths, and branch news. It gives a fascinating insight into the company. During World War I, a section titled "With the Colors" highlighted those Larkin employees who were engaged in the war. John D. Larkin strived for his company to be a family. These programs put that belief into concrete action.

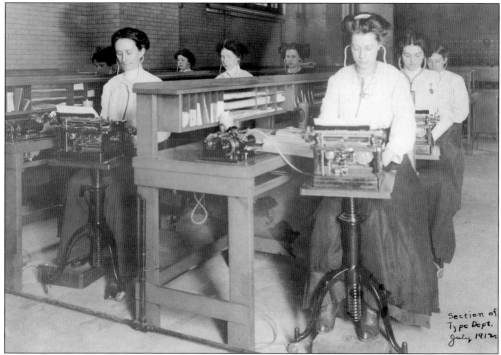

This image from 1912 shows female employees in the typing-transcription department, located on the second floor of the Larkin Administration Building. These workers would transcribe verbal orders and records from other departments that were recorded onto wax phonograph cylinders. With thousands of letters and orders coming into the factory on a daily basis, this streamlining measure was taken to reduce paperwork and to make the workplace easier to manage for employees.

Here is a 1920 image of the girls' dormitory at 48 Seymour Street, just north of the factory. Opened in 1905 and managed by the Larkin branch of the YWCA, also established in that year, it was home for up to six women who "by reason of location or otherwise are deprived" of home advantages.

The Larkin baseball team was one of many social programs developed for Larkinite men and women. It participated in industrial leagues popular throughout the 1900s–1920s, playing against other factories and companies. The welfare program policy grew in response to the quick expansion of the number of employees and the seeming disconnect between them and management. This image is from 1906.

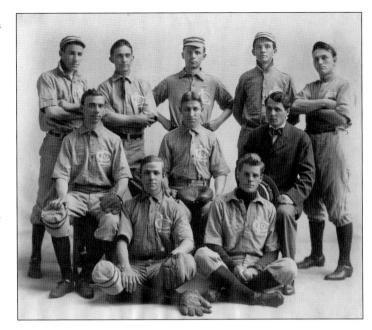

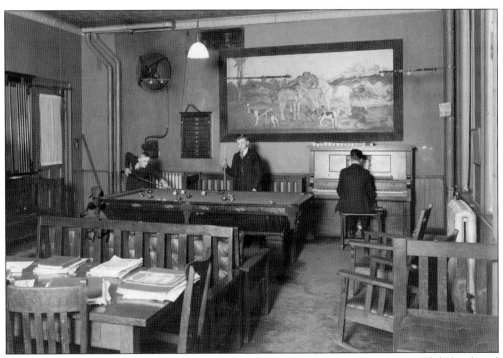

There were a few clubs devoted to young men and boys. In 1912, the Young Men's Club developed under the guidance of the Larkin YWCA. Other clubs for young and teenage boys included the Get There Club and the Larkin Boys Club. The recreation space included billiards and musical equipment, as shown here, and sporting events such as basketball, baseball, bowling, and golf.

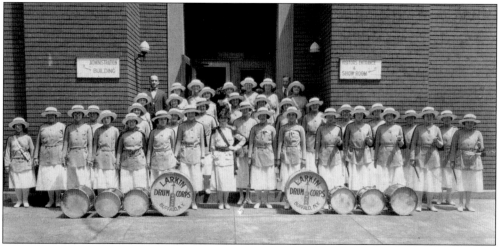

The Woman's Drum Corps, shown in this undated photograph, was organized in 1919 under the direction of Capt. Louise C. Gerry, the YWCA personnel director. Throughout most of that first year, the company practiced for its first parade, which was held in September. While the group mostly performed throughout Buffalo, western New York, and New York state, the drum corps did travel to Denver, Colorado, in 1926 to play at the Rotary International Convention. Out of this group came the Girl's Orchestra.

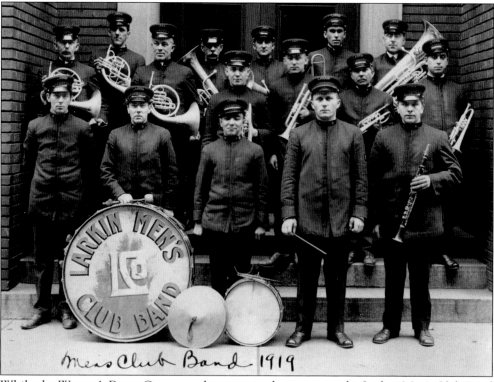

While the Woman's Drum Corps may have received more press, the Larkin Men's Club Band developed earlier. The band had up to 20 musical instruments and was marketed as accompaniment to dances and other occasions. They also performed against other industrial bands from around Buffalo and western New York. Here are 16 members of the band in 1919.

The employee dental office is shown here in 1917. Opened in 1915 in the Service Building adjacent to the Larkin Administration Building, employees were able to take advantage of the services at a flat company rate, as opposed to an itemized bill. The dentist, Dr. Hussong, is shown with an unidentified nurse. Examinations and estimates of cost were also furnished for free to Larkin employees.

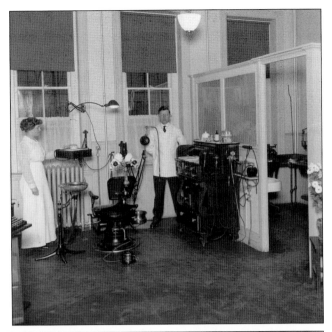

Here is a view of the doctor's office and women's restroom for office employees. The factory and the office each had their own doctor's office, dispensary, and rest area. Showing the progressiveness the Larkin Company prided itself with, the doctor in charge of each office was female. The functions of each office were threefold: to consult, give advice, and treatment; to give care and treatment after accidents; and to provide physical examinations of applicants and employees.

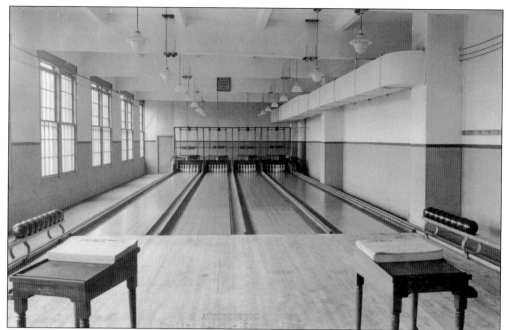

According to information on this image of the employee bowling alley, it was located in the powerhouse, Building I, although no other information could be found tying the bowling alley to the powerhouse. Other documentation places it on the first floor of Building U. Regardless, Larkinites took to bowling with a league of 16 teams. Some team names included the Sweet Homes, Honor Brights, Baby Dolls, Yankee Tanks, and Ducky Doos. These teams would compete at Goodell Lanes, located at 36 Goodell Street in downtown Buffalo.

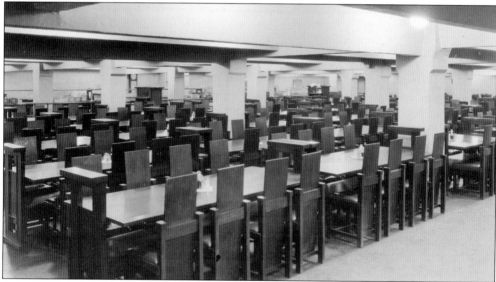

A small employee restaurant opened in 1903 on the site of the future Larkin Administration Building. When constructed in 1906, the fifth floor of the administration building housed an employee and visitor restaurant. In 1916, a separate factory restaurant opened, and by 1920, both restaurants were combined into Buildings J and K. The 30,000-square-foot cafeteria is shown here, located in the basement of Building J.

The Larkin Plan of Co-Operative Ownership was one of the ways the Larkin Company tried to engage its employees. This plan ultimately failed due to its complexity and executive-level disagreements. If an employee had worked at the company for three years, was at least 21 years of age, and was a citizen of the United States—all as of January 1, 1919—they were eligible to be a charter employee stockholder. The plan was phased out of existence by 1921.

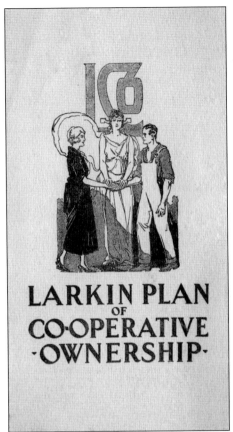

LARKIN PLAN
OF
CO·OPERATIVE
·OWNERSHIP·

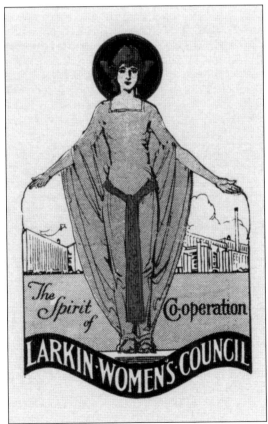

Very early on, the Larkin Company established a YWCA for its female employees. The branch had roughly 780 members by the mid-1910s. It also managed the dormitory shown on page 102. By 1925, the Larkin Woman's Council, whose logo is shown here in 1928, replaced the Larkin Y and continued its religious, educational, and recreational activities.

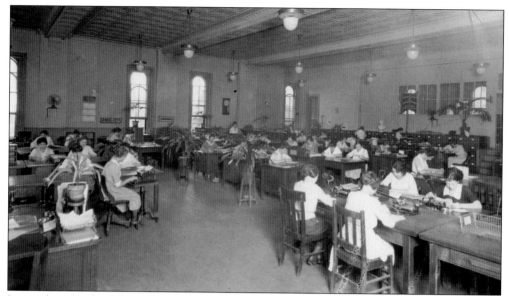

Located on the third floor of the Service Building was the Larkin school, where employees could take various courses. Starting in 1907, any worker employed for six months or longer at the company could take advantage of an off-site educational reimbursement program or the company library. Throughout the 1910s, the educational department continued to grow with classes in English for newly arrived immigrants and home economics courses such as cooking, sewing, and cleaning.

Here, Larkin workers are preparing for the Larkin Pageant, hosted at Delaware Park in 1916. Called *The New Vision: A Masque of Modern Industry*, it was performed in front of 9,000 spectators. The themes of the play were staples of the Larkin Company, namely that industry only works through cooperation, order, harmony, and excellence. The man at center facing left with his hand on his hip is Dr. Hussong, the company dentist shown on page 105.

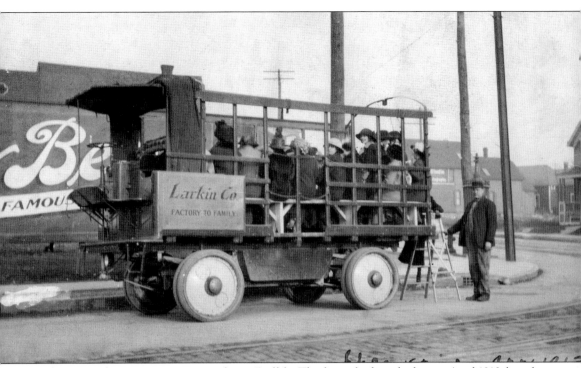

There were three major streetcar strikes in Buffalo. The first, which took place in April 1913, lasted almost a week, from April 6 to April 12. The employees of the International Railway Company (IRC), disgruntled over perceived low wages and working conditions, felt officials of the company would not meet with the drivers and conductors. This, and subsequent strikes, gave rise to jitneys, personal busses or automobiles used to transport customers to and from work. These jitneys not only charged outrageous fares, much more than the IRC, but they rarely observed traffic laws, causing many accidents around Buffalo and Erie County. The Larkin Company, holding true to its tenets of community and cooperation, used Larkin delivery trucks to transport employees to and from work. Other streetcar strikes occurred in 1918 and 1922, both of which lasted longer than the first one. Here is a Larkin delivery truck in 1913 transporting Larkinites to and from work.

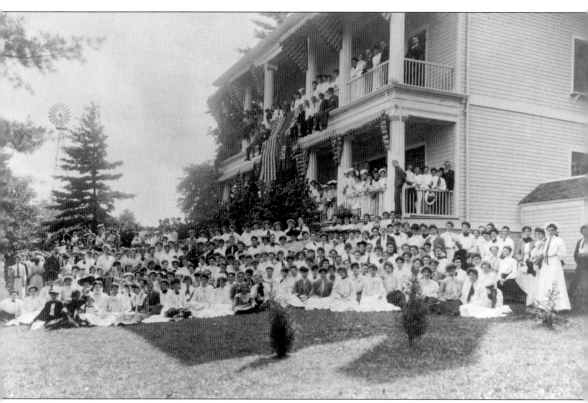

Glen Cairn, the Larkin family summer home in Queenston, Ontario, Canada, was purchased in 1900 and previously owned by the Rumsey family as their summer home. John D. Larkin's mother, Mary Ann Durrant, was born in England but settled in Canada before marriage, and John showed a soft spot for the northerly neighbor throughout his life. When the Larkins purchased the home, Frances Larkin immediately tended to the garden and grounds, developing an English garden and, a few years later, a Japanese garden with a tearoom. Here is an undated image of Glen Cairn during a Larkin Picnic, which John and Frances hosted for employees. Summertime as a Larkin employee offered many excursions or "Echo's" to places near and far. Other summer activities included Field Days, begun in 1907 and usually held on a Saturday in July at Cascade Park, near Springville, New York; travels to Silver Bay, a community on Lake George, New York; and hikes to Woodlawn Beach, just south of Buffalo, and at Eagle Bay, New York.

Seven

ADVERSITY, REFINEMENT, SYMPATHY
THE END

Dr. Howard Stanger highlights various factors for the company's demise beginning, ever so slightly, in 1921. The growth of national chain stores like A&P and Woolworths, along with the growth of the automobile, made the "new thing" to go and shop for oneself. Mail order houses were all of a sudden considered slow and outdated. The Larkin Company also relied heavily on women—as Larkin Secretaries and club members. With the United States' participation in World War I, thousands of women entered the workforce and began demanding more equal rights. This took the primary customer away from the Larkin Company. These events began in the 1910s but did not show their effects until 1921 and 1922. The Great Depression in 1929 also weakened the measures the company was taking to right this slowly sinking company. Finally recognizing the mail order business was changing, it diversified into retail food markets, gasoline stations, home craft stores, and a large department store. While these showed some profit buoyancy for the company (see page 115), they were not individual profit makers. The company stopped making soap in 1939 and stopped all manufacturing of products and premiums in 1941. The company established the Larkin Store Corporation to try to liquidate all remaining merchandise. The company had so much remaining product that it was able to fill mail orders until 1962, with the last order shipping to Marie Mills in Philadelphia. The company became a warehouse concern and rented its enormous space to other companies to keep money flowing. In 1937, it sold 78 of its remaining food retail stores to another local company, Danahy-Faxon, and in 1940, it sold its 10 remaining gas stations to North American Refining Co. Ltd. for $175,000. In 1967, the company, at that time named Larkin Warehouse Inc., sold the last of its properties to a company called Graphic Controls, shutting the Larkin doors for good.

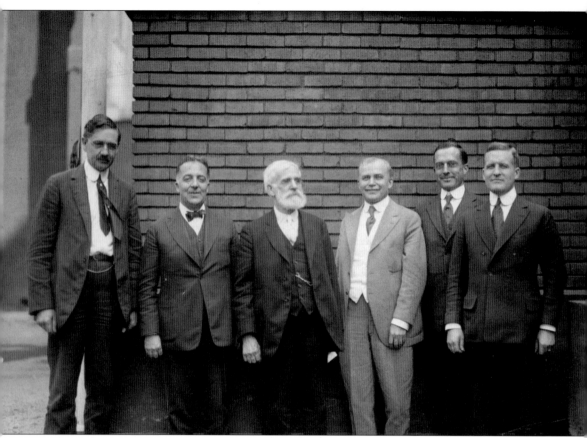

The Larkin executives are shown around 1918. From left to right are William R. Heath, John D. Larkin Jr., John D. Larkin, Darwin D. Martin, Harold M. Esty, and Walter B. Robb. William R. Heath joined the company from Chicago, after he married the sister of Frances, John D. Larkin's wife. He headed up the legal department and became vice president, with his influence shown in *Ourselves*, the company newsletter. John D. Larkin Jr. joined the company after his older brother, Charles, resigned. He became vice president and assistant treasurer and eventually president of the company when his father passed. Darwin D. Martin joined the company in 1878 through his brother Frank. Darwin was 13 years old and was the second office worker at the company after John D. Larkin. Harold M. Esty married one of John D. Larkin's daughters, Frances, known as "Daisy." Walter B. Robb, who joined the company in 1914, was assistant treasurer and eventually a vice president. Robb married John's daughter Ruth. Among the internal factors that brought about the Larkin Company's demise were the sudden changes from 1924 to 1926 to this executive team.

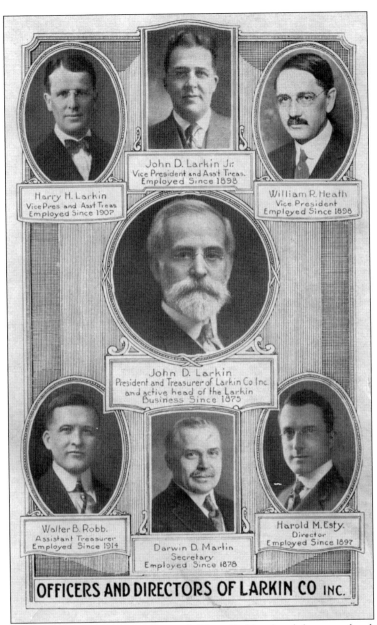

John D. Larkin Jr.
Vice President and Ass't Treas.
Employed Since 1898

Harry H. Larkin
Vice Pres. and Ass't Treas.
Employed Since 1907

William R. Heath
Vice President
Employed Since 1898

John D. Larkin
President and Treasurer of Larkin Co Inc.
and active head of the Larkin
Business Since 1875

Walter B. Robb.
Assistant Treasurer
Employed Since 1914

Darwin D. Martin
Secretary
Employed Since 1878

Harold M. Esty.
Director
Employed Since 1897

OFFICERS AND DIRECTORS OF LARKIN CO INC.

The severing of John D. Larkin's relationship with Elbert Hubbard and the messy legal and personal battles that ensued for the next five years guided Larkin's leadership style for the rest of his life. Hubbard left the company during the financial panic of 1893; those external, national forces had hurt the Larkin Company. Hubbard's insistence on stock buybacks and promissory payments almost brought the company to its knees. From that moment, Larkin vowed that those closest to him and his company would be family—by blood or marriage. In 1924, William R. Heath retired from the company and Harold M. Esty became ill and died. In 1925, Darwin D. Martin retired from the company frustrated with John D. Larkin Jr.'s plans for the business. In 1926, John D. Larkin passed at the age of 80. From 1924 to 1926, the company had lost 151 years of combined institutional knowledge and guidance—a loss it was never able to recover from. Here is an image of the officers and directors of Larkin Company from 1921.

BOX RIDGE,

PURLEY,

SURREY.

John D.Larkin Esq. May.28.15
Buffalo. N.Y:U.S.A.

Dear Mr Larkin
 I enclose a letter received too late for
last mail from Mr Harkness,the Assistant Purser of the
"Lusitania". He has returned the photos I left with him.
I am afraid we must give hope of recovering the bodies
now, I have no doubt they are still in the ship. Mr H
was not a man to get panicky or rush for the boats,but
those who were so seem to be the only ones picked up.
I wonder if you have seen before the cutting I enclose
from the "Boston Post"of May 11th. It is very interest-
ing and characteristic.
This has been an unlucky week for us in the Dardanelles
having two of our warships torpedoed. It is becoming
evident to all that we had little idea of what Germany
was preparing for Europe in their determination to win
world power. We have closed up our ranks,formed a nat-
ional Government,and will seriously tackle the problem.
Of course we will win,but the terrible price we must pay
for want of foresight and preparation will,I hope,be a
warning to the United States. I am afraid very few of us
expect the end of the war before next spring,although a
few weeks ago we were confident it would end in the fall.

I hope that your interests are not being injuriously af-
fected in the States by it,and that you will find things
to balance. Some people are making big money out of the
war but others are serious losers,but losing the flower
of our youth is the worst of all.
Trusting you are all well,and with best regards
 Believe me faithfully yours
 John Allen

Over the years, John D. Larkin's relationship with Elbert Hubbard was creative, profitable, and emotionally draining. The Larkins were incensed that Elbert Hubbard's affair with a suffragette and feminist named Alice Moore was making the newspapers, and it affected Frances, Larkin's wife and Hubbard's sister. As time drifted away from 1893, the year of Hubbard's messy exit from the Larkin Company, the relationship again changed. Hubbard had wished to be a writer and left to follow that path. He established the Roycroft Movement in 1895 in East Aurora, New York, which blossomed into one of the finest arts and crafts communities in the United States. By the time of World War I, the Hubbards and Larkins had reestablished the bonds of friendship and family, though at a distance. Traveling on the RMS *Lusitania* in 1915, both Elbert and Alice, now his second wife, were lost when a German U-boat sank the ship. The family held out hope for a few days that they had just gone missing after the attack and would be found. The sinking occurred on May 7, 1915, and this letter to John D. Larkin on May 28 from John Allen, a business associate who lived in England, shows that by then all hope was lost.

This memo from Larkin employee J.F. Place to Darwin D. Martin in 1921 shows a drop of 45.7 percent in sales from 1920, the high-water mark for the company. The table lists the amount of sales needed each week for the rest of the year to make up the difference. To equal 50 percent of the total 1920 sales, the company would have had to sell $236,405 worth of product each week for the duration of 1921.

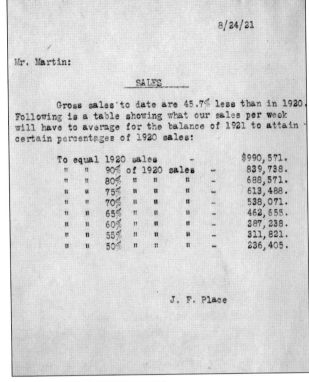

8/24/21

Mr. Martin:

SALES

Gross sales to date are 45.7% less than in 1920. Following is a table showing what our sales per week will have to average for the balance of 1921 to attain certain percentages of 1920 sales:

To equal 1920 sales					-		$990,571.
"	"	90%	of 1920	sales	"	-	839,738.
"	"	80%	"	"	"	-	688,571.
"	"	75%	"	"	"	-	613,488.
"	"	70%	"	"	"	-	538,071.
"	"	65%	"	"	"	-	462,655.
"	"	60%	"	"	"	-	387,238.
"	"	55%	"	"	"	-	311,821.
"	"	50%	"	"	"	-	236,405.

J. F. Place

Year	PRoduct & Premium sales	Other Sales	Total
1906	$14,342,103		14,342,103
1907	14,903,000		14,903,000
1908	12,808,976		12,808,976
1909	14,468,562		14,468,562
1910	15,737,283		15,737,283
1911	15,479,979		15,479,979
1912	14,655,286		14,655,286
1913	17,945,512		17,945,512
1914	15,805,664		15,805,664
1915	15,746,675		15,746,675
1916	17,078,947	977,861	18,056,808
1917	14,905,103	1,461,071	16,366,174
1918	12,315,622	3,082,989	15,398,611
1919	15,021,729	5,196,074	20,217,803
1920	15,490,789	7,400,233	22,891,022
1921	9,250,000	4,440,685	13,690,685
1922	9,751,000	4,030,279	13,781,279
1923	13,670,455	4,321,441	17,996,896
1924	12,510,293	4,642,478	17,152,771
1925	11,980,073	5,112,048	17,092,122
1926	10,211,448	5,219,420	15,430,868
1927	10,466,068	4,686,980	15,153,048
1928	9,725,639	5,101,844	14,827,483
1929	9,635,391	5,942,173	15,577,564
1930	7,464,977	5,799,315	13,264,292
1931	4,954,059	6,420,467	11,374,526
1932	2,927,144	5,670,024	8,597,168
1933	2,237,897	5,689,960	7,927,857
1934	2,439,219	6,074,308	8,531,527
1935	2,331,318	6,511,752	8,843,070
1936	2,201,834	6,807,353	9,009,187

This ledger lists the total sales for the years 1906–1936 and shows the steep drop in profits beginning in 1921. The company's profits were offset by "Other Sales" such as grocery and retail stores, gas stations, and lease agreements with other companies within its factory, but it was not enough to offset its main products and premium sales, shown in the column second from left.

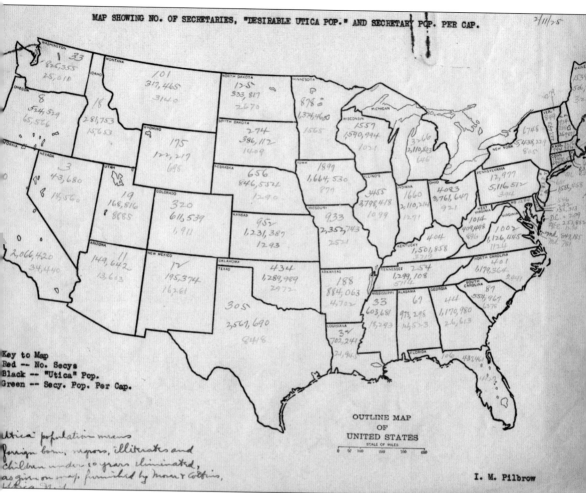

Key to Map
Red -- No. Secys
Black -- "Utica" Pop.
Green -- Secy. Pop. Per Cap.

Utica population means
foreign born, negroes, illiterates and
children under 10 years eliminated,
as given on map furnished by Mount Collins.

OUTLINE MAP
OF
UNITED STATES
SCALE OF MILES

I. M. Pilbrow

Within each state boundary on this map of the United States, three things are listed. The number of Larkin Secretaries within each state; the "Utica" population—the population of each state not including "foreign born, negroes, illiterates, and children under 10 years of age"—or the population of each state that the Larkin Company believed could afford to purchase its products; and the population per capita based on the Larkin Secretaries. For example, at the time of this 1925 map, New York state had 6,748 Larkin Secretaries, the Utica population was 5,438,299, and there were 805 New Yorkers for every secretary. Coinciding with an index (not shown) created with this map, the Larkin Company had 56,943 secretaries across the country. That was down from 90,000 just five years prior in 1920. The state with the most Larkin Secretaries was Pennsylvania, with 12,977 and a per capita population of 394 people per secretary. The information contained within this map gave the company a better understanding of its prospective customer base.

116

John D. Larkin is pictured in 1920 sitting at his desk in the Larkin Administration Building. His office was located at the south end of the first floor, adjoining the cashier and accounting office and the offices of his sons John Jr. and Harry H. These offices along Seneca Street were semiprivate with half walls. The other executives, Darwin D. Martin and William R. Heath, were at the opposite or north end of the administration building along Swan Street.

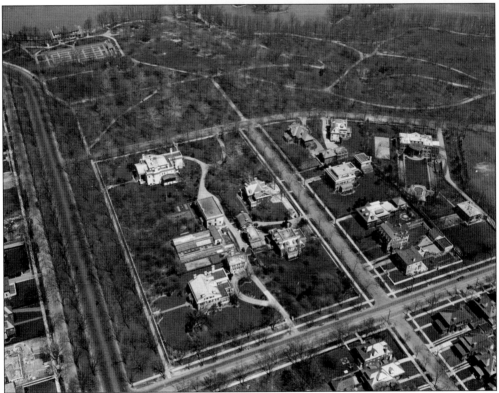

John D. Larkin greatly provided for his family. Larkland, the Larkins' homestead complex, is pictured here in 1924. Bounded by Forest Avenue, Rumsey Road, Lincoln Parkway, and Windsor Avenue, Larkland included five homes, all distinctly and deliberately not in the Wright style used by other Larkin executives. Larkin constructed a house for him and his wife and children, John Jr., Charlie, Harry, Ruth, and Frances. Some houses were passed to other family members as people moved.

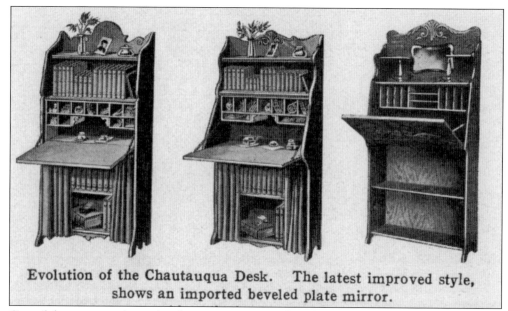

Evolution of the Chautauqua Desk. The latest improved style, shows an imported beveled plate mirror.

One of the most popular and earliest premiums was the Chautauqua desk, introduced in 1892. First paired with the Combination Box, the desk brought the company $87,000 in gross profits per year until 1920. This image shows the evolution of the desk through the years, to address customer needs and wants. By 1910, the beveled plate mirror was included. The desk was made of solid oak with a golden oak finish.

With upwards of 5,000 letters, orders, and correspondence coming into the Larkin Company daily, Darwin D. Martin instituted an extensive card ledger system. Started in 1885 to replace the bound volume indexes, the complexity of the card ledger escalated in 1886 with the creation of the Combination Box. Accounts payable, accounts receivable, correspondence, running records, and interdepartmental correspondence all were addressed. Many walls in the Larkin Administration Building, like this one, were dedicated to the card ledger system.

The decline of the Larkin Company was slow and plodding, but consistent. Soap manufacturing stopped in 1939, and all manufacturing was halted in 1941. The company shuttered 10 business lines across manufacturing, sales, and services. The Larkin Company limped along until 1962, when its last mail order was shipped. This letter sent to customers in 1962 informed them that the company was ceasing mail order operations.

HARRY H. LARKIN
PRESIDENT

Larkin Co.
DIV. LARKIN WAREHOUSE, INC.

189 VAN RENSSELAER STREET
BUFFALO 10, N. Y.

HARRY H. LARKIN, JR.
SECRETARY

HOWARD H. MASSING
VICE-PRESIDENT

Larkin Warehouse, Inc. has ceased the operation of its mail order division and henceforth will devote all of its efforts to the operation and expansion of its public warehousing business.

Larkin Co. Division is no longer filling orders for Larkin Products or any of the merchandise shown in its catalogs. Catalogs, order blanks or other literature are no longer available.

Service or parts for merchandise such as electric appliances, clocks, watches, dinner ware, sewing machines, cutlery, furniture, housewares, etc., formerly offered in Larkin catalogs should be secured direct from the manufacturer. Matching pieces for Noritake China are no longer available.

Mail you recently sent to us is being handled as indicated below.

Larkin Warehouse Inc.

☐ Order for products and any remittance included is returned to you herewith as received.

☐ Inquiry regarding merchandise or parts should be referred to manufacturer.

☐ Material requested no longer available.

Here is John D. Larkin in his office on the 50th anniversary of the company, May 1, 1925. In the morning on that day, Larkin was greeted with a gold-lined silver memorial cup, shown behind him. For five hours, from 10:00 a.m. to 3:00 p.m., Larkin greeted many employees with a handshake and a commemorative plaque. This event "made a deep impression on all who stopped to contemplate its significance, and was a day of congratulations and happy memories for our President."

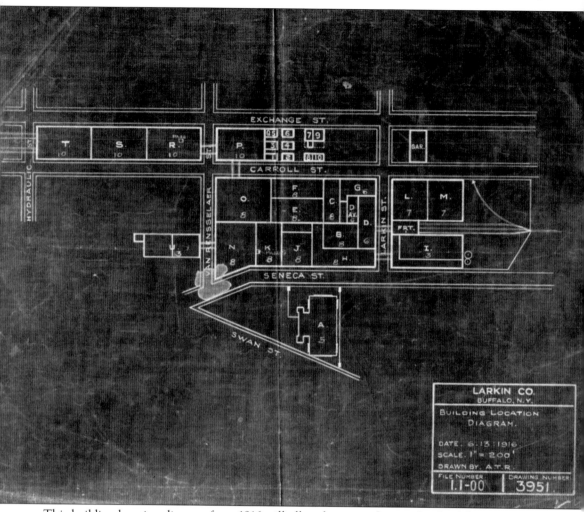

This building location diagram from 1916 will allow for easy reference for the following index of buildings and floors. The image orientation is reversed: north is at the bottom, and south is at the top.

INDEX OF
BUILDINGS AND FLOORS

The information for the Larkin Administration Building comes from "My Trip Through the Larkin Factories" by Marion Harland, 1912. Information for all other buildings comes from a 1931 Sanborn map surveyed by J.A. Graham.

BUILDING A: LARKIN ADMINISTRATION BUILDING

Floor One: executive offices, statistics, employee sales, accounting, auditing, invoicing, buyers, and editorial staff for *The Larkin Idea* and catalogs
Floor Two: sales, accounting teams divided by state and country, transcribers, and stenography
Annex: dispensary with a nurse, three rooms, and five beds
Floor Three: sales, accounting, inward and registered mail, and the 400-volume library
Floor Four: sales, accounting, and inquiry department
Floor Five: restaurant, kitchen, bakery, two rooftop gardens, and Inspiration Point

BUILDING B

Floor One: kettles and old machinery
Floor Two: kettles, old machinery, baled paper, cloth, wood files, and desks
Floor Three: storage of old machinery, wood lockers, frames, and shelves
Floor Four: cooking kettles
Floor Five: cooking kettles
Floor Six: kettles and storage of wood framing

Floor Seven: cooking kettles and storage for cardboard and paste
Floor Eight (Partial Floor): general storage

BUILDING C

Basement: storage of vinegar in wood barrels
Floor One: storage of groceries, and shipping and receiving of market goods
Floor Two: storage of flour bleaching compounds in metal cans and glassware in wood cases
Floor Three: general storage, bakery, and storage of soap and canned goods in cartons
Floor Four: storage and empty wood boxes
Floor Five: storage of paper boxes, cardboard, and wood barrels
Floor Six: Jane Elizabeth Candy Company: candy making
Floor Seven: general storage and bonded warehouse
Floor Eight: general storage and research lab

BUILDING D

Basement: The Office Toilet Supply Company
Floor One: kettle room and storage of beverages and malt syrup

Floor Two: kettle room and offices department
Floor Three: kettle room and laundry
Floor Four: kettle and framing room
Floor Five: soap crushing, lye and mixing tanks, and storage of syrup
Floor Six: soap crushing and remelting and lye storage

BUILDING D ANNEX

Floor One: kettle room
Floor Two: kettle room and glycerin department
Floor Three: kettle room
Floor Four: kettle room
Floor Five: storage of beet pulp
Floor Six: general storage

BUILDING E

Basement: kitchen
Floor One: storage of groceries and canned goods
Floor Two: dishwashing, storage of sugar, empty cartons, baled paper, and storage of idle equipment
Floor Three: storage of cardboard, printing ink, and baled scrap paper
Floor Four: washing and storage of bottles
Floor Five: toilet power grinding and filling; storage of denatured alcohol, borax, and salts; and perfume and pharmaceutical storeroom
Floor Six: grinding, sifting, and mixing of toilet powder
Floor Seven: dead automobile storage
Floor Eight: storage of malt in burlap sacks, alkali in wood barrels, and denatured alcohol and solvents in metal drums

BUILDING F

Floor One: storage of ink and lead
Floor Two: shipping and receiving
Floor Three: storage of charcoal, canned goods, soap, and eggs
Floor Four: storage of sugar in burlap bags, printing ink in metal cans, flour, canned goods, soap, and soap chips

Floor Five: perfume and pharmaceutical department
Floor Six: perfume and pharmaceutical department
Floor Seven: pharmaceutical department

BUILDING G

Floor One: refrigeration room and storage of empty glass bottles and sugar in bags
Floor Two: Lucidol Corporation: manufacturer of flour bleaching compounds, storage of flour and storage of bleaching compound in metal cans
Floor Three: Lucidol Processing Corporation, scrap wood, and general storage
Floor Four: storage of empty metal containers
Floor Five: general storage
Floor Six: Jane Elizabeth Candy Company, starch and candy molding department

BUILDING H

Basement: repair shop, refrigerating plant, pipes, new and old machinery parts
Floor One: refrigeration room
Floor Two: offices and storage of soap cuttings
Floor Three: laundry soap drying and cuttings and soap packing
Floor Four: storage of soap chips and uncut soap
Floor Five: soap chips and pumice filling, toilet soap milling, and soap chip dryers
Floor Six: dry room, soap scouring, and mixing
Floor Seven: cleanser filling machine and storage of cleanser in paper cartons
Floor Eight: Boraxine department, storage of cleanser in wood barrels, and borax making

BUILDING I: POWERHOUSE

Floor One: piping, ash pits, and blowers
Floor Two: fire pumps, transfers and autos, and generators: three 115 kw, three 300 kw, two 70 kw, one 750 kw, and one 110 kw
Floor Three: The Office Toilet Supply Company and laundry

Floor Four: glycerin plant and lab
Floor Five: glycerin plant and economizer

BUILDING J

Basement: cafeteria, storage of bargain basement supplies, and office records
Floor One: store
Floor Two: wholesale china store, storage of crockery, dishware, and hotel supply stock room
Floor Three: storage of soap chips and bath soap
Floor Four: storage of porch hammocks, toys, chairs, china, and glassware
Floor Five: toilet soap packing and storage of wood trays, toilet soap, and cleaning compound
Floor Six: dead automobile storage
Floor Seven: making of macaroni, noodles, and spaghetti
Floor Eight: general storage

BUILDING K

Basement: bargain basement
Floor One: store
Floor Two: tea toom
Floor Three: storage of postcards, envelopes, and paper
Floor Four: storage of paper tissues, stoves, ice boxes, washing machines, and hardware
Floor Five: storage of bottled goods in hardware
Floor Six: coffee packing and storage of coffee, slip covers, and paper boxes
Floor Seven: drying of noodles, macaroni, and spaghetti

BUILDING L

Basement: storage of damaged sugar
Floor One: Craver Dickinson Co., storage of feed in burlap bags, and storage of trucks and old machinery
Floor Two: storage of burlap bags, seed grain in burlap bags, soap stock tanks
Floor Three: storage of gluten feed and seed grain and soap stock tanks

Floor Four: storage of seed grain and gluten feed in burlap bags and storage of new machinery
Floor Five: storage of gluten feed in burlap bags
Floor Six: grease storage tanks
Floor Seven: storage of gluten feed in burlap sacks and grease storage tanks

BUILDING M

Basement: storage of fats and oils in wood casks
Floor One: rosin mixing tanks, storage of roofing materials, and storage of blending lubricating oil
Floor Two: storage of lube oil and alkalin in wood barrels, Sears & Roebuck public storage
Floor Three: soap stock and sweet water tanks, rosin storage, Sears & Roebuck public storage
Floor Four: storage of empty metal drums and treatment and storage of fats and oils
Floor Five: storage of fats and oils
Floor Six: storage of fats and oils and seed grain and filter presses
Floor Seven: fat melting and storage

BUILDING N

Basement: lumber storage and salvage department
Floor One: department store
Floor Two: library furniture, rug store, storage of unclaimed baggage, dispensary, and restrooms
Floor Three: printing
Floor Four: finishing and storage of furniture
Floor Five: storage of buttermilk pulp
Floor Six: packing of mustard, spices, peanut butter, fillings, and puddings and storage of paper boxes and cartons

BUILDING O

Floor One: storage of lumber, alcohol, ammonia, witch hazel, and bay rum
Floor Two: shipping and receiving
Floor Three: Barry Food Corporation:

manufacturer of baked beans, brown bread, and mayonnaise; and storage of radios, unclaimed baggage, and washing machines
Floor Four: several wood partitions, photography rooms, and storage of paper and paint
Floor Five: storage of toilet articles
Floor Six: box wood storage and crating and box repairing
Floor Seven: storage of seed grain

BUILDING P

Basement: piping
Floor Two: general storage, office, and lunchroom
Floor Three: paint stock room
Floor Four: Millington Lockwood Co. Inc: storage of stationary, glassware, old records, and office supplies
Floor Five: storage of catalogs, packing cardboard, and cardboard cartons
Floor Six: furniture repairing and storage of wood repair parts
Floor Seven: upholstering, mattress and cushion padding, and storage of furniture
Floor Eight: woodworking and cabinetmaking
Floor Nine: chair spraying and dipping, and finishing and repairing of furniture

Q BUILDINGS

Q 1: demolished
Q 2: demolished
Q 3:
 Floor One: linseed and chinawood oil storage tanks
 Floor Two: storage of paint in metal drums and mixing
 Floor Three: mixer reparing
 Floor Four: storage of lamp black and zinc oxide
Q 4:
 Floor One: varnish storage tanks
 Floor Two: packing
 Floor Three: paint mixing
 Floor Four: storage paint pigments and zinc oxide
Q 5: storage of varnish

Q 6: storage of varnish
Q 7: storage of metal vats
Q 8: storage of metal tanks

BUILDING R

Basement: piping
Floor One: shipping and receiving and freight terminal
Floor Two: Curtis Publishing Co., Hygeia Nursing Bottle Co., Tiger Products Co., H.B. Trevor Co., Headstrom Union, and B.F. Goodrich Co.
Floor Three: The Harshaw Chemical Co., Goodman & Graves Inc. offices, Fairbairn & Hartmayer Inc., B.F. Goodrich tire storage
Floor Four: F.H. Leggett & Co., Rossville Co., storage of canned goods, and storage of alcohol
Floor Five: selecting of perfumes and toilet articles
Floor Six: packing and storage of spoons and food choppers
Floor Seven: sewing and dressmaking
Floor Eight: storage of soap, canned goods, powdered buttermilk, furniture, toilet paper, and fan blades
Floor Nine: Davis Leather Inc., rug storage, and packing and storage of furniture
Floor Ten: storage of furniture and radios and radio assembly and testing

BUILDING S

Basement: piping
Floor One: shipping and receiving and freight terminal
Floor Two: storage of electric refrigerators and Hygeia Nursing Bottle Co. packing and receiving
Floor Three: storage of refrigerators, seed corn, and Nachman Spring Filled Corp.: bed springs
Floor Four: storage of china in wood cases
Floor Five: packing of perfumes, toilet articles, and canned goods
Floor Six: storage of clothing and sweaters and US Post Office card and mail sorting
Floor Seven: sewing and pressing of dresses and cloth goods

Floor Eight: storage of soap flakes, powdered skimmed milk, wheat paste, canned goods, safety matches, grease, and motor oil in metal drums

Floor Nine: storage of glass and enamel ware

Floor Ten: storage of lamps, baby carriages, chairs, stools, wash tubs, chests, and metal ware

BUILDING T

Basement: piping

Floor One: shipping and receiving and freight terminal

Floor Two: general storage

Floor Three: storage of leather, raw silk, and household items

Floor Four: storage of chemicals in metal and wood barrels, dried skim milk, flour, powdered buttermilk, and rope and racking materials

Floor Five: storage of handkerchiefs, sponges, household items, china, crockery, bathroom articles, hose, cutlery, paint brushes, and tinware

Floor Six: storage of canned goods, leather, auto heaters, medicine, toilet paper, and bottle caps

Floor Seven: cloth cutting, laying-out tables, and storage of cloth

Floor Eight: storage of starch, oil soap, canned goods, washing machines, straws, and electric motors

Floor Nine: storage of linoleum and wallpaper

Floor Ten: storage of chairs, lampshades, lawn mowers, and oats and garden seed in burlap sacks

BUILDING U

Floor One: storage of pipes, old machinery, and lubricating oil and bowling alleys

Floor Two: storage of lumber and woodworking, machine shop, and sheet metal working

Floor Three: storage of corrugated paper in rolls, electrical supply room, and offices

Floor Four: equipment storage, sign shop, and maintenance paint shop

BIBLIOGRAPHY

Buffalo History Museum Research Library, B76-1, Darwin D. Martin Personal Papers and Larkin Company Records.

Buffalo History Museum Research Library, Mss. C85-1, Larkin Company Records.

Larkin, Daniel I. *John D. Larkin: A Business Pioneer*. Buffalo, NY: Buffalo and Erie County Historical Society, 2006.

Osgood, Sharon. *Larkin Memo Book: 1899–1903*.

Ourselves. Larkin Company, 1903–1926.

Quinan, Jack. *Frank Lloyd Wright's Larkin Building: Myth and Fact*. Cambridge, MA: MIT Press, 1987.

Stanger, Howard R. "From Factory to Family: The Creation of a Corporate Culture in the Larkin Company of Buffalo, New York." *The Business History Review* vol. 74, no. 3 (Autumn 2000): 407–433.

———. "Failing at Retailing: The Decline of The Larkin Company, 1918–1942." *Journal of Historical Research in Marketing* vol. 2, no. 1 (2010): 9–40.

———. "Ourselves: Welfare Capitalism in the Larkin Company, 1900–1939." *The Industrial Relations Research Association Proceedings* (2003).

The Larkin Idea. Larkin Company, 1901–1913.

Williams, Charles H. *Photographs of the Pan American Exposition held in Buffalo May 1, 1901 to November 1, 1901*.

Other resources included the photographic collection of the Larkin Company, the Buffalo History Museum photographic collections (General Collection and Goldome–Nagel), Buffalo History Museum ready reference and vertical file resources, the Buffalo Collection at the Buffalo and Erie County Public Library, and Buffalo city directories.

INDEX

DISCOVER THOUSANDS OF LOCAL HISTORY BOOKS FEATURING MILLIONS OF VINTAGE IMAGES

Arcadia Publishing, the leading local history publisher in the United States, is committed to making history accessible and meaningful through publishing books that celebrate and preserve the heritage of America's people and places.

Find more books like this at
www.arcadiapublishing.com

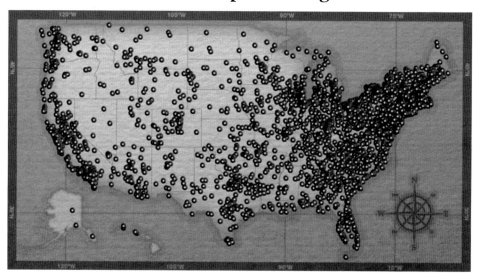

Search for your hometown history, your old stomping grounds, and even your favorite sports team.